THE NEW
COLOR MIXING
COMPANION

THE NEW
COLOR MIXING
COMPANION

Explore and Create Fresh and Vibrant Color
Palettes with Paint, Collage, and Mixed Media

JOSIE LEWIS

Brimming with creative inspiration, how-to projects, and useful information to enrich your everyday life, Quarto Knows is a favorite destination for those pursuing their interests and passions. Visit our site and dig deeper with our books into your area of interest: Quarto Creates, Quarto Cooks, Quarto Homes, Quarto Lives, Quarto Drives, Quarto Explores, Quarto Gifts, or Quarto Kids.

© 2019 Quarto Publishing Group USA Inc.
Text, projects, and templates © 2018 Josie Lewis

First Published in 2019 by Quarry Books, an imprint of The Quarto Group,
100 Cummings Center, Suite 265-D, Beverly, MA 01915, USA.
T (978) 282-9590 F (978) 283-2742 QuartoKnows.com

Quarry Books titles are also available at discount for retail, wholesale, promotional, and bulk purchase. For details, contact the Special Sales Manager by email at specialsales@quarto.com or by mail at The Quarto Group, Attn: Special Sales Manager, 100 Cummings Center, Suite 265-D, Beverly, MA 01915, USA.

10 9 8 7 6 5 4 3 2

ISBN: 978-1-63159-549-3

Digital edition published in 2019

Library of Congress Cataloging-in-Publication Data

Names: Lewis, Josie, author.
Title: The new color mixing companion : explore and create fresh and vibrant
 color palettes with paint, collage, and mixed media / Josie Lewis.
Description: Beverly, MA, USA : Quarry Books, an imprint of The Quarto Group,
 2018. | Includes bibliographical references and index.
Identifiers: LCCN 2018027748 | ISBN 9781631595493 (trade pbk.)
Subjects: LCSH: Color in art.
Classification: LCC ND1488 .L49 2018 | DDC 701/.85--dc23 LC record available at https://lccn.loc.gov/2018027748

Design and Page Layout: Laura Klynstra
Photography: Amy Anderson Photography

Printed in China

MIX
Paper from
responsible sources
FSC® C016973

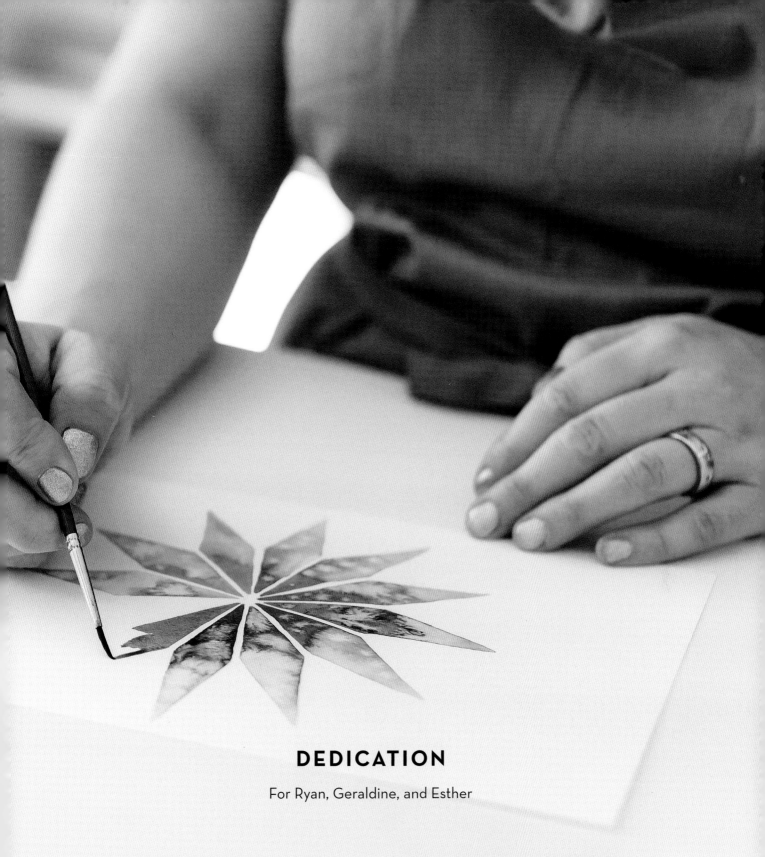

DEDICATION

For Ryan, Geraldine, and Esther

Contents

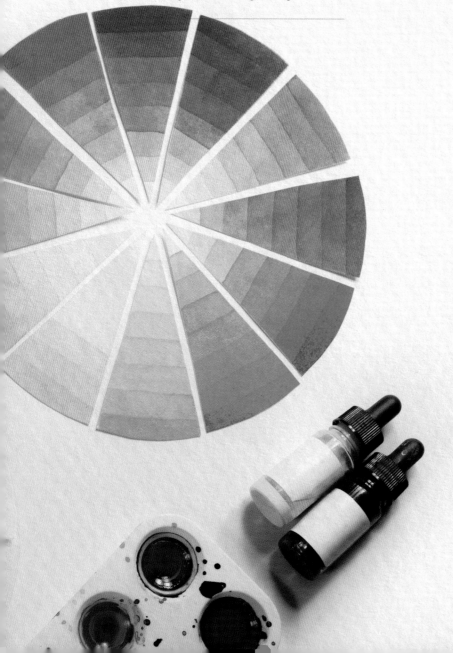

2

Preface

I had the privilege of speaking to a nonartist group about the power of art and leading them in a watercolor exercise. After the lecture, a man in his 60s approached me. He was visibly moved, nearly weeping. He told me: "I was in prison in my 20s, and they sent me to painting class. But the thought of art terrified me, and for the whole two weeks of the class I never even picked up the paintbrush. When I think about all the absurd risks I took in my life as a criminal, I just can't believe I couldn't take risks as an artist."

This story is profound for many reasons, but I think it's all about identity. Making a choice to, say, rob and assault someone proves the robber's deepest conviction that he is the kind of person who needs to take value forcibly from someone else in order to have worth or to assert physical dominance to create an "impression." That person is asserting his belief that that's all he has to offer. People take those kinds of risks willingly (to devastating consequences), but being faced with the generative and non-violent act of creativity can be terrifying. That's because making the choice to push past fear of failure and make something is embodying the powerful idea that *you have something worthwhile to say.*

Though this book is about color and painting in particular, it's important to emphasize that creativity includes so much more than just visual art. We need creativity in literally every area of our lives. The basic function of creativity is releasing old solutions and generating new ones. Creativity is at the root of the scientific method, all kinds of technological advances, and every breakthrough, large and small, in every human effort—ranging from parenting to surgery. This book invites you to joyfully welcome and nurture your generative powers. You were born to be creative. It's one of the most essential human endowments. My ex-con made his first painting that day.

Opening up to the creative possibilities that call to you is risky. Your first attempts will be wobbly, like a newborn horse. But carry on, because *you have something worthwhile to say.*

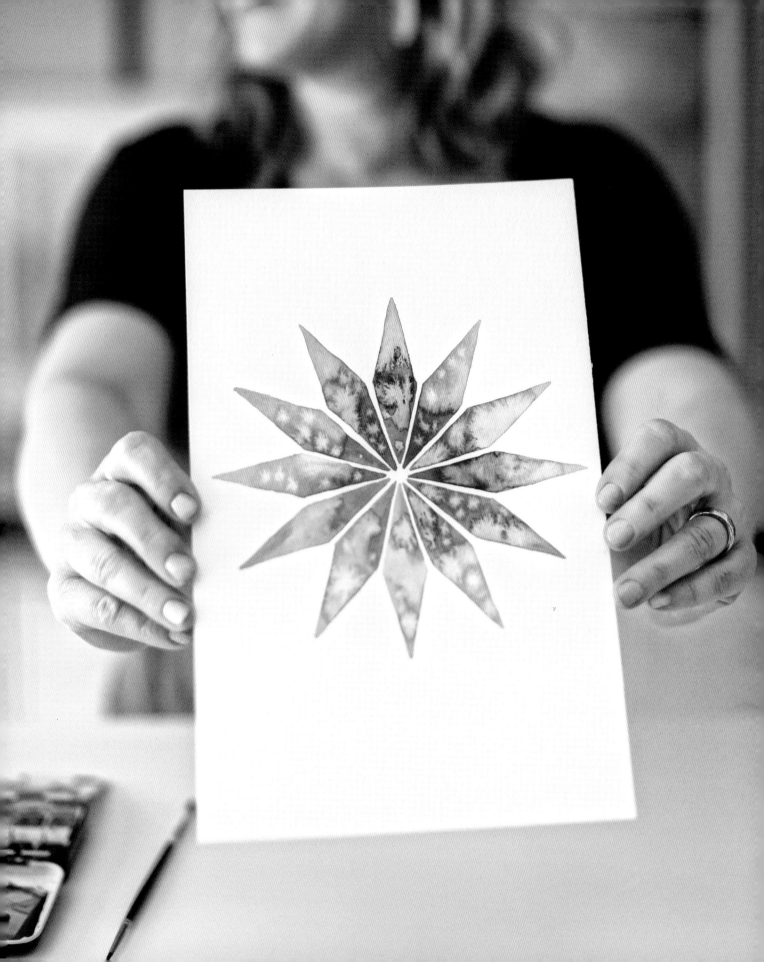

An Introduction to Color

So we know now that color is all an illusion (see "Color Doesn't Exist," below), but I'm basically obsessed with the color wheel. I love circles, I love rainbows, I love grids, and I love Sir Isaac Newton (1643–1727), who invented the wheel.

I've been making color wheels and charts for years. I don't usually follow all the rules exactly, preferring instead to make a chart or a wheel that suits my subjective preferences. But in this case, I made a legit wheel. I attempted to mix the truest, wheel-iest, rainbow-ist colors I could find. I've been told with paint you can mix all the colors through the three primaries (red, blue, and yellow + white), but I haven't found that to be the case.

Have you ever noticed how many shades of red are available in paint? Hundreds. Some are great for mixing orange, some are great for mixing purple, pinks, earth tones, flesh tones, etc.—but I've never found a single red that can do it all. So for this project I used two blues, one violet, one green, two yellows, and about six reds. (Red is a tricky one to nail down—I haven't found the Holy Grail red yet.)

See the opposite page for a breakdown of basic color terms I use in this book.

COLOR DOESN'T EXIST

As usual, physics defies everything you've ever known to be true by indicating that color doesn't actually exist the way we usually think of it. Color, or rather the sensation of color, is an optical illusion based on reflected light. Color is actually more accurately described as "texture." That is, every object has some sort of reflective surface. Depending on the type of surface, visible light will reflect off the surface of a thing in various ways and give us the impression of a color. Thus, color is not inherent to the object; the color is *in the light* between your eyeball and the object. White things have a very reflective surface and lots of light bounces off; black things absorb a lot of light. This basically means you've never actually seen the surface of any object, because the light from the object is interfering with your vision. To quote the movie *The Matrix*, "It's the world pulled over your eyes."

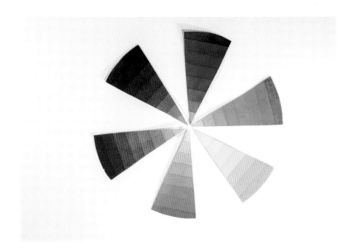

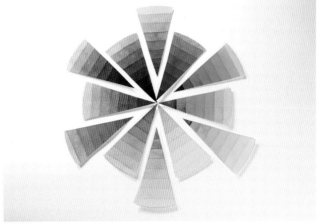

Primary colors. Blue, red, and yellow.

Secondary colors. Purple, orange, and green. Each secondary color is a mixture of the two primaries shown on either side of it on the wheel.

Tertiary colors. Further "in-between" colors, seen here as pop-outs. A tertiary is made by mixing a primary and a secondary shown on either side of it on the wheel.

COLOR WHEEL GROUPINGS

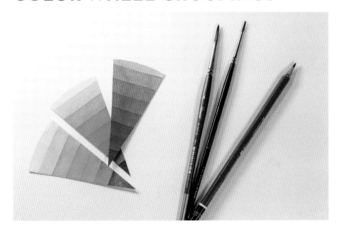

Monochromatic colors. One or more value shifts of the same color.

Analogous colors. Two or more colors that are next to each other on the wheel. Shown at left: green, blue-green, and blue.

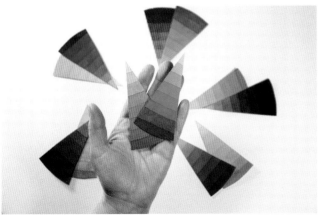

Complementary colors. Two colors that lie opposite one another on the wheel. Shown here: blue-green and red-orange.

Main Color Techniques: Around, Across, Up, and Down

I use a lot of different mediums, but I'm usually trying to achieve one thing—seamless color transitions. *The glow.* I love all things ombré, gradients, tiny stripes close together, pointillism in painting, neon radiance, traffic lights reflected on wet pavement, Mexican serape blankets, rainbows, and, naturally, the color picker in Photoshop.

There are three ways I shift colors. They are:

- **Around the Wheel**
- **Across the Wheel**
- **Up and Down Value**

Around the wheel

When I shift colors *around the wheel,* I use high chroma, high-intensity, extra-saturated colors found on the color wheel. Saturation or chroma is the level of intensity of a color. A highly saturated color will have no gray, no white, and no black. The colors are all pure hue. The transitions are based on the blend of the rainbow spectrum. Blue changes to turquoise changes to green, for example. Using a range of color shifts from around the wheel will result in all high-key, saturated colors with equal dominance across the whole composition.

Across the wheel

When I use colors *across the wheel,* I transition colors between their complementary color on the opposite side of the wheel. Green gets mixed with red in various ratios to create olive green and oxblood. Blue gets mixed with orange to create stormy gray and muted pumpkin. The colors that stretch the divide *across* the complementary colors will be toned-down versions of themselves trending to gray.

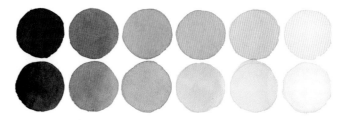

Up and down value

Up and down value adds dimension to your color. Colors across and around the wheel are essentially colors on the same value plane. If you add value progressions, you change the lightness or the darkness of a color. The colors go up (lighter) or down (darker). This means adding white (a tint) or adding black (a shade).

THE MOTHER METHOD

If you've ever had kombucha, please know that the way it gets made is that there is something called a "mother" in a big vat of tea. The mother is the most disgusting thing you've ever seen. It looks like a slimy, mottled, fatty organ of a strange beast. It's a concoction of bacteria and yeasts. It's really quite alarming. Like yeast in bread and live cultures in yogurt, the kombucha mother permeates the whole brew. As a metaphor, it perfectly applies to painting! The Mother in paint means a single color remains on your paint tray, always informing the next mix, instead of mixing up a completely new color each time. If you start with a Mother color on your palette and continually tweak that color, you will be able to create lovely gradients and color shifts. There are a lot of different ways to utilize The Mother in paint mixing, and I will refer to it frequently.

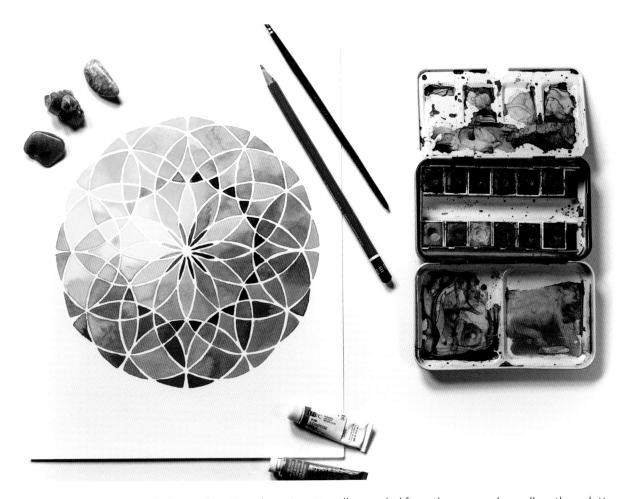

This painting shows evidence of The Mother. To make it, I continually sampled from the same color well on the palette, gradually adding new colors until the entire painting shifted.

Studio Supplies

THE GOLDEN RULE OF STUDIO SUPPLIES: START CHEAP

Oh, art supplies. There are so many art materials in the world. You'd think I'd be invigorated by the possibilities, but I find the volume of art-supply-store choices to be really stressful. It's like everything in there is a magic wand and, if you know the spell, you can make something amazing. But all the magic wands start at $9.95 for one color. And you need thirty-five. And there are cheaper magic wands over there, but maybe they're just as good? And what's the difference between madder lake and quinacridone magenta anyway?

And then there is that Instagram artist who makes their thing look amazing and easy, and you rush to get their kit. But if I want to buy, say, a basic set of six colors and a paintbrush or something, it will probably cost $200 . . . and then you might not even like it. For sure your efforts will fall far short of the professional who's been using that media for sixteen years. So my policy is: Start cheap.

Here is a truism across all categories: You can always spend more money. In some cases (but not all), you get what you pay for. Deciding on the caliber of material (and cost) depends on your goals. Are you trying to play and learn? I find that if I'm using expensive materials, my play pleasure and learning capacity is radi-cally diminished because I'm so aware of the costs of everything. I get precious, perfectionistic, and miserly. Cheap supplies are better when I'm learning (p.s., I never stop learning). For instance, I have a few nice, framed watercolor paintings and a lot of "used" water-color paper. Better for me to use cheaper paper and then I won't have a cha-ching noise dinging in my head every time I make a lousy painting. However, there does come a point when you're trying to further develop your skills. Once I begin to develop a language or style in a medium, I often choose to upgrade my supplies. As I get better, it helps if my materials also get better.

For sourcing, art supply stores are great. Amazing, beautiful, abundant, usually with knowledgeable salespeople, one stop and easy. I also source and shop around online. There are frequent sales and coupons, fast and free shipping is usually the norm, and it's easy to find good prices. In addition, some of the big craft stores stock high-quality art materials, and if you can get the coupons and sales, they can be an economical option.

The projects in this book fall into three broad cat-egories: acrylic paints, collage, and watercolors. See each section on page 15–19 for details on specifics.

ACRYLIC PAINTS

Acrylic paints are a modern invention made with pigments suspended in a polymer emulsion. They are water soluble and dry into a waterproof film that resembles a plastic skin. They are versatile, can be inexpensive, and have no odor.

For the acrylics projects in this book, I use:

- Student grade/craft acrylic kit in six to eight colors + plenty of white

- Favorite colors: magenta, crimson, cadmium red light, lemon yellow, phthalo blue, lilac, and basic purple
- Palette knife (I like the plastic ones with a small, triangular knife)
- Disposable palette
- Premade, primed canvases in various sizes
- 90 lb. (165 g/m²) all-purpose paper
- Paper towel for cleanup

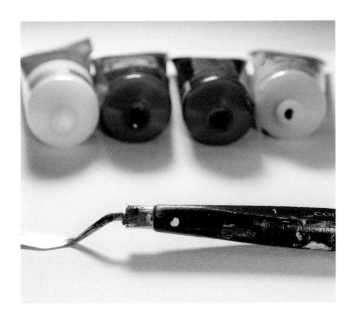
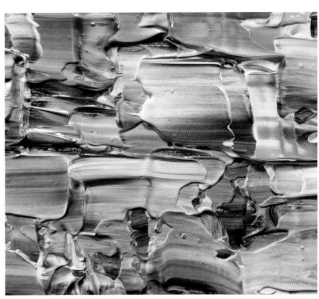

ACRYLICS PROJECTS

Title	Skill level	See page
Glorious Extravagance	Beginner	24
The Classic Schmear	Beginner to Advanced	38
The Freud	Beginner	54
Whipped Rainbow	Beginner to Moderate	62

COLLAGE

Here's the good news about collage: You can't really improve much on the cheap supplies. You can get fancier glue that won't wrinkle your paper and use any kind of substrate from paper to canvas to board. You can also coat a finished collage with Mod Podge or resin for protection, but the beauty of collage is the simplicity. The collages in this book are generally quick exercises—collage is a great way to do color sketches—for which I use multicolored card stock with various sheens and textures. This type of paper is abundant at any craft store.

For the collage projects in this book I use:

- Magazines, old books, old paintings on paper, colored card stock from the craft store, recycled paint chips
- Glue sticks
- Scissors
- 11" x 15" (28 x 38 cm) white mixed-media paper, 90 lb. (165 g/m²)
- 18" x 24" (45.5 x 61 cm) white mixed-media paper, 90 lb. (165 g/m²)
- Paper punches in various sizes and shapes

COLLAGE PROJECTS

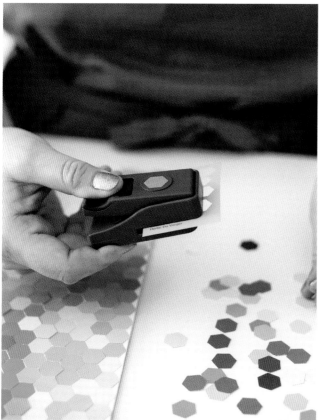

WATERCOLORS

I have had a long-term, on-and-off-again relationship with watercolors. As they say, it's complicated. I mean, I love watercolors. I loooooooooove them. All those colors you can just fit right in your pocket. The ease. The versatility. The luminosity. But they're also maddeningly capricious. To me, watercolors are like a charming but inconsistent boyfriend who's hard to dump. I mean, watercolors and I totally have a codependent relationship. They have so much promise, so many delightful colors, they bring me flowers and sweet nothings, and then *destroy* me with their intransigence. The bad-boy-friend watercolors fail me repeatedly, but then I let them come over because they have so much potential. I can't trust 'em, but they are so charismatic. With regularity I say, I'm moving on! That's it! I'm kicking you to the curb! There are plenty of other art supply fish in the sea, like oil paints and resin and gouache. But then those half-pans call to me, so seductively, so enticing, so "easy," and the 140 lb. paper feels so nice, and

honestly how much harm could there be to just drink some wine and paint a few hexagons? Netflix and chill, anyone? But then the next morning I see what a mess I made of my studio, with limp and unsatisfying paintings lying around everywhere, and no one even made me breakfast. Watercolor, I shake my fist at you! (But I love you, never leave me.)

For a list of supplies I use for the watercolor projects in this book, see "Watercolor Kit" on the opposite page.

The majority of the watercolor projects use templates; all of them can be found at the end of this book and can also be downloaded for free from www.josielewis.com or quartoknows.com/page/color-mixing so that you can either scan and print them on your own watercolor paper or download and print them directly.

Note that using stencils or a punch and tracing the shapes is a versatile way to make your own painting templates. Use a pencil with a very hard 6H graphite, which is so light that it disappears when you paint over it.

WATERCOLOR PROJECTS

Title	Skill Level	See page	Template required?
Mini Mono	Beginner	28	No
Value Gradient Primer	Beginner	44	Yes; see pages 139–140
What Happens If	Beginner	58	No
Q*bert	Beginner	66	Yes; see page 141
Dots	Moderate but Helpful for Beginners	74	Yes; see page 142
Waiting for the Diamonds	Moderate	84	Yes; see pages 143–144
Seed of Life	Moderate	92	Yes; see pages 145–146
Diamond Crystals	Moderate	96	Yes; see pages 147–148
Sashiko	Moderate to Difficult	114	Yes; see page 149
Radiating Diamonds	Moderate	118	Yes; see page 150
Antagonistic Complements	Moderate	122	Yes; see page 151
Faded Hex	Moderate	126	Yes; see page 152
Working with Neutrals	Moderate to Advanced	130	Yes; see pages 142, 153, 154, 155

WATERCOLOR KIT

One of the reasons I stay true to watercolor is that the supply kit is so small and transportable, I can easily fit what I need in my handbag. I've painted on mountains, kitchen tables, couches, front stoops, and park benches, and in trains, planes, canoes, and cars.

Colors. I have palettes with fifty or more colors available. I have used dozens of brands. But I find that I go back to the same colors over and over, so I finally edited my collection down to the essentials. I used that color palette exclusively in the projects in this book. This exact palette of twelve professional pan colors in the cutest foldout travel palette is available for purchase on my website (see Resources), but if you prefer to source your own colors, equivalents are as follows:

- Opera Pink
- Quinacridone Coral
- Pyrrole Orange (Transparent)
- Lemon Yellow
- Phthalo Yellow Green
- Phthalo Green Blue
- Manganese Blue
- Ultramarine Turquoise
- Phthalo Blue (Red Shade)
- Indanthrone Blue
- Imperial Purple
- Naphthamide Maroon

Mixing tray and palettes. I use a foldout mixing palette with the paints in the center and several ridged areas to mix paint. I also occasionally use a mixing palette with small wells like shallow egg cartons. I use the palette with wells when I need to mix up a quantity of a color.

Brushes. I use round watercolor brushes in sizes 2, 4, 6, and 8. My brushes range from $3 to $5 each. I do not use the budget brushes (say, twenty for $10). I've never once in my life come across an even slightly acceptable brush that was included for free in a cheap paint kit. The budget brushes often have scraggly bits and lose their bristles all over your painting, which is lame. You ain't got time for that.

Paper. Watercolor paper is sometimes measured in grams per square meter (g/m^2) or pounds (lbs.). The heavier the weight, the thicker the paper. Watercolor paper comes in cold press, hot press, or rough. I use 140 lb. cold press, which has a slight tooth and is my usual preference. The heavier you go, the pricier the paper, and the better the paper will withstand repeated layers and resist pilling and warping.

Tape. I usually tape the corners or the edges of whatever I'm working on. I use white artist's masking tape because colored tape (like blue painter's tape or even the standard beige) interferes with my ability to accurately see the colors I'm working with. A benefit to using white artist's masking tape is that it's less sticky, meaning it will be less likely to damage your paper when you remove it.

Other stuff. You'll also need:

- Paper towels = invaluable
- Scrap paper for color testing
- Table salt and rubbing alcohol

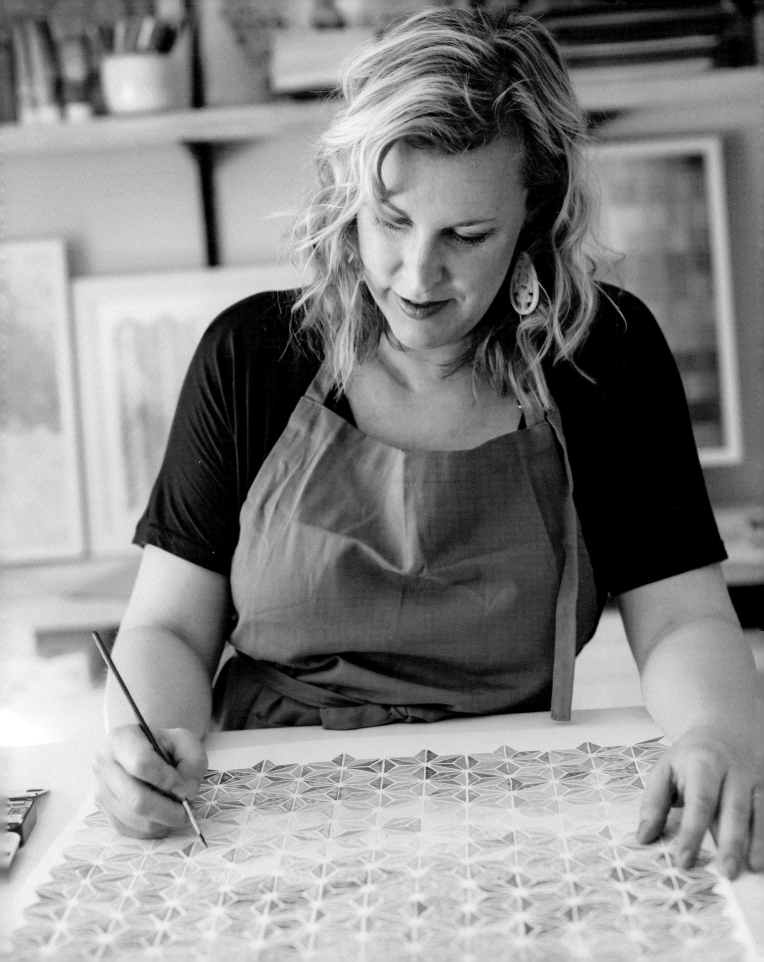

Why I Paint

I have some bad news, friends. Life sucks. Seriously, there are hurricanes and mass shootings and war and infidelity and cancer and betrayals and human trafficking. There are less bad things, like weak coffee and seaweed and small talk and mall parking ramps during the holidays. Every single day of our lives we will have an opportunity to face sorrow and tragedy, small and large. Sometimes that sorrow will be remote, a disaster we see on the news. Other times that sorrow will be nose to nose, right in our own homes and hearts.

You may be wondering where I'm headed with this talk of woe in a book about joyful rainbow colors. Seems incongruent, no?

My very personal experience with tragedy is this: I lost my second baby at birth. A full-term birth is very different from a miscarriage. There's the usually demanding process of birth, and then a funeral to plan. My body provided milk for the little one that was not. The grieving and physical recovery process was excruciating.

I'm pretty sure the way to deal with grief and loss is to actually go through it. As they say, "If you're going through hell, *keep going*." But we humans generally don't like experiencing painful emotions, so we really try to avoid them. We avoid them by repression and distraction, but that deflection results in a dulling of our emotional capacity across all spectrums. But if we agree to walk through our losses with our hearts open, how do we survive? How do we recover?

During some of the very, very low points over the weeks and months after our baby's birth/death, I started to notice that I would actually feel somewhat "normal" when I was making art. At my art table, I became deeply immersed in color patterns. There was something powerful about the repetition and focus it required. Everything would slip away—my grinding sadness, my sore body, even my hormonal craziness. Making my color patterns would fully connect me to the present moment. I found the art process helped me cope through the storm and aided my recovery in body and spirit.

We are in an ongoing state of tension between the unavoidable tragedy that's part of this journey, and the utter beauty, love, and awe that is available to us at any given moment. Paradoxically, experiencing grief can actually augment our experiences of beauty and love.

I will say more about why making art had such a powerful effect on processing grief later in this book, but for now I will simply say that color grounded me through the most wrenching experience of my life. It has convinced me that a creative life is imperative to make us fully human.

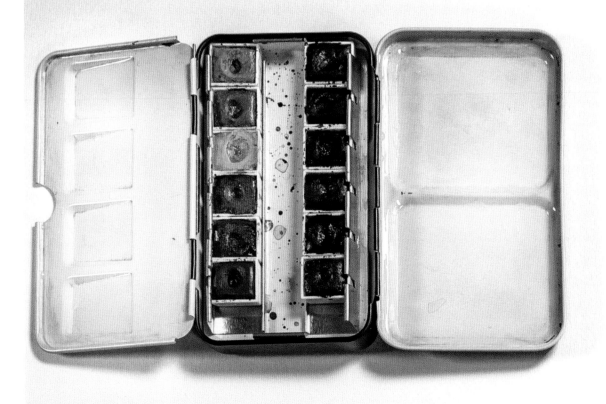

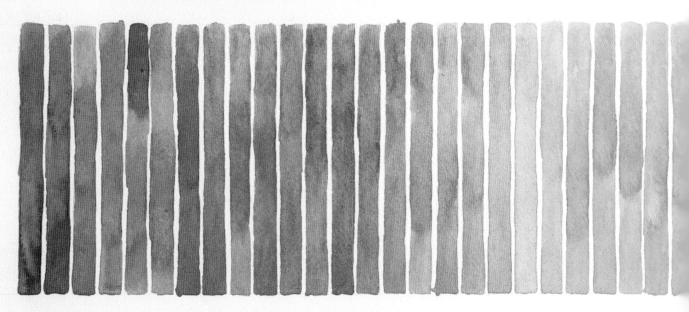

1
Starter Projects

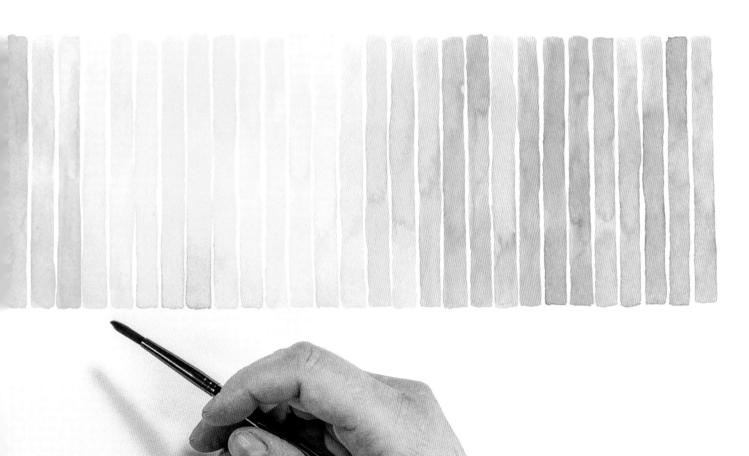

Glorious Extravagance

First, a brief history lesson. Before the Industrial Revolution, artists had to make their paint by hand, and they stored it in pig bladders. For real. At some point in the mid-1800s, paint tubes with a screw cap were invented and companies began mass-producing paint for artists. Van Gogh (1853–1890) was one of the first painters who squeezed paint directly onto his canvas. The invention of mass-produced paint and aluminum tubes directly led to the expressionist painting movement, which 125 years later led directly to *this project*.

As we know, art supplies cost money. As a result, it's easy to get miserly and precious with them and work on tiny little projects with tiny little outcomes. For this project, however, a required mindset will be "I am going to use all the paint." You may or may not actually use all the paint, but you want to get used to the idea that the paint you just paid hard-earned money for is going to be used, possibly all of it. Even, gasp, wasted. I generally don't like to waste things I paid cash money for, but you've got to take a risk to get a break.

SKILL LEVEL
Beginner and up

SKILLS LEARNED
Basic color mixing, and how to be excessive, abundant, over the top, leading to reckless joy

MATERIALS
15" x 15" (38 x 38 cm) prestretched and primed canvas
3–5 tubes of acrylic paint + large tube of white
Palette knife

MESS LEVEL
Potentially off the charts; take precautions

TIME TO COMPLETE
60 minutes

MORE FOR LESS

The 4 oz. (118 ml) acrylic paint tubes are usually the best value. Student-grade paint is perfect for this because you're going to use loads of it, so you can at least be thrifty with a lower quality. You'll want extra white paint. The stiffer the paint, the better—you don't want paint that's too liquid.

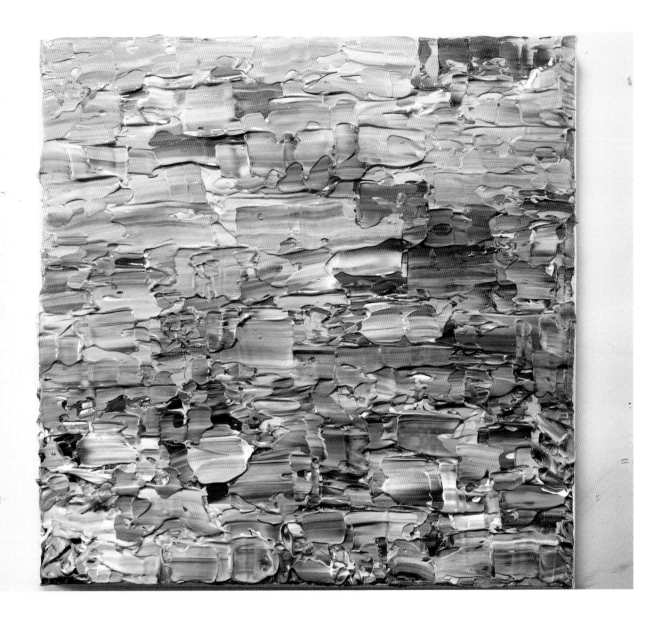

CHOOSING COLORS

Limit your color range to three to five tube colors plus white or things will get muddy real fast. I used magenta, deep yellow, and turquoise. If you're interested in the color theory, these tertiary colors are in a triadic combination—not the red, yellow, and blue of your primary colors but one click over on the wheel. This makes the combination feel a little more grown-up and less primary school.

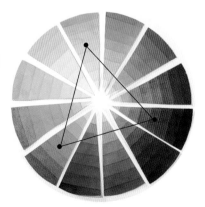

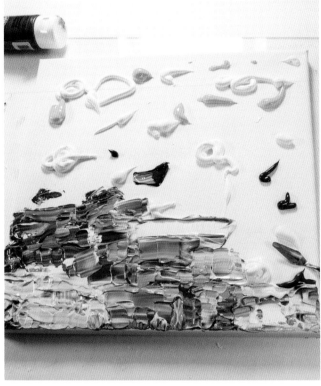

1 Get your canvas ready by laying it flat and squeeze white all over. Add color here and there straight out of the tube. Be bold. You won't need a brush for this project, but you will need a small, flexible palette knife. There are a lot of different shapes and sizes. I like the diamond-shaped ones, and this project works better with a smaller knife.

2 Using the knife, start smushing the paint around. The first lesson of this project is *waste paint* and the second lesson is *don't overwork*. You'll be mixing the colors with the white and with one another, but you'll have a big pile of mud real fast if you overmix. You want to dash in and dash out, and once you've piled up some paint in one area, move on!

GO EASY

You are using your palette knife like you're frosting a cake (yum)—verrrrrry gently. Whatever is on the bottom of the palette knife will end up on the surface of your painting. It's helpful to wipe the excess paint off the palette knife occasionally to clean things up.

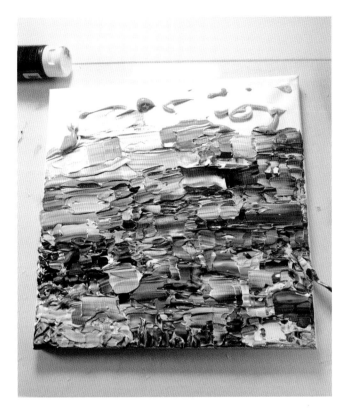

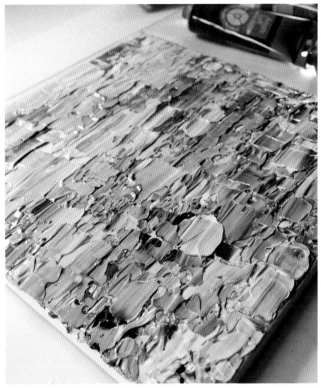

3 Your goals: Completely cover the entire white surface of the canvas, and create interesting textures. There should be some areas where you've mixed the paint completely, and other sections where the paint is only barely mixed and showing contrast and dimension. You've covered the whole canvas?

4 Stop! The painting will take a good while to dry—possibly even three to four days, depending on your humidity and thickness of paint, so put it somewhere safe and wait. You have now learned some wonderfully reckless life skills that can be applied to almost any situation (abundance! joy! liberation!), plus you made an amazing painting.

COLOR COMMUNITY

Use #colorcompanion to tag your projects to join the social media color community.

Mini Mono

Established artists have rules. They may not call them rules. In fact, it may be offensive to even suggest to them that they have rules because artists often base their whole careers on *breaking* rules and conventions. (Question: If your "rule" is breaking the rules, wouldn't the most rebellious act be compliance? Asking for a friend.) Rules, order, and structure seem to be "uncreative." The perception is that the whole point of being an artist is that you can do *anything you want*. But the fact is most artists who have spent time developing their voice make their work within very structured systems. They might work with a certain medium. They work with certain colors. They use repetitive lines or marks. They revisit a consistent subject. Naturally, there are time-honored situations when a well-known artist changes everything they do (think Picasso, Blue Period). But at its heart, design and creativity are all about finding your voice within the bounds of a medium or a technique, and the only way to do that is to narrow the possibilities and, yes, apply rules.

I conceived this project with very rigid guidelines: one color, one shape, one size. In the beginning I had about five turquoise circle ideas. Then I ran out of ideas, and I decided it was a stupid and extremely boring project and it was likely that I also was stupid and boring. But when I was working on the last painting before I stopped, I had another idea. And that next painting led to another idea. Sometimes the ideas would be directly linked to the previous painting in an obvious way, but sometimes my mind would just wander and a new turquoise circle plan would introduce itself. It got to where I was dreaming about turquoise circles, and I'd have turquoise circle ideas in the shower and in the car. It actually started to inform my other work, and overall this exercise helped me learn a lot about composition and paint, and added new tools to my arsenal of visual language.

SKILL LEVEL
Beginner

SKILLS LEARNED
Designing your own template; using stencils; monochromatic painting

MATERIALS
12-color watercolor kit (see page 19)
#1, #4, and #8 round brushes
Paper towel
140 lb. (300 g/m²) watercolor paper cut in 5" (12.5 cm) square swatches

MESS LEVEL
Minimal

TIME TO COMPLETE
A few minutes for one

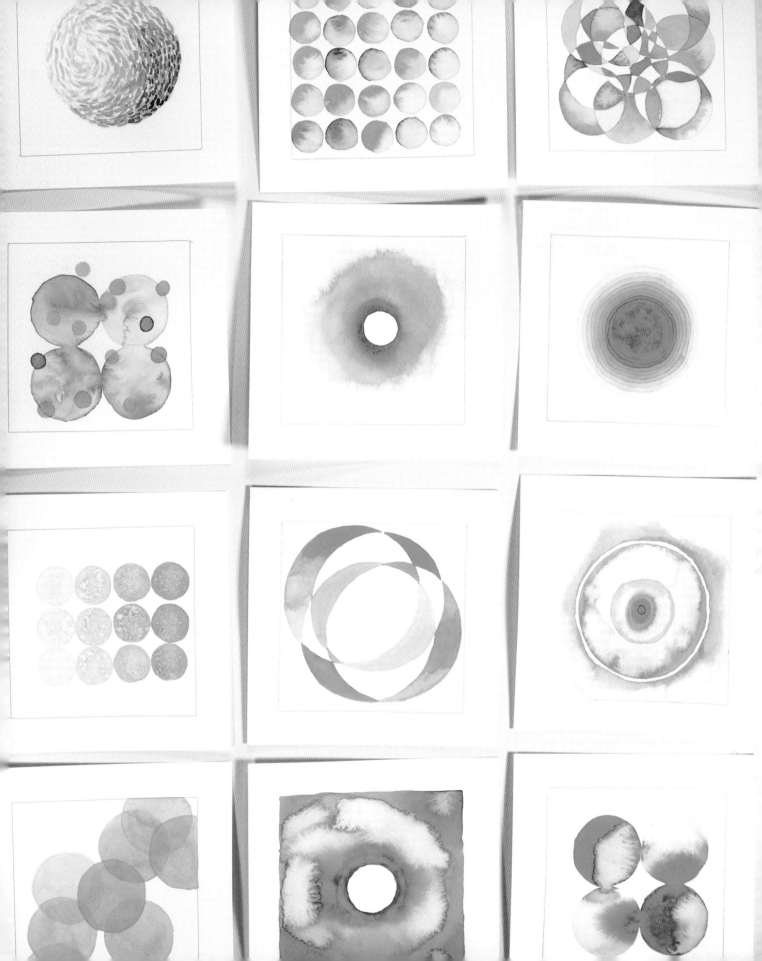

1 Cut watercolor paper into approximately 5" x 5" (12.5 x 12.5 cm) pieces. If you're working with a 9" x 12" (22.9 x 30.5 cm) pad, you could do a 4.5" (11.5 cm) square. Let your source paper size be your guide so that you don't waste paper. How many you cut is up to you—for this project I made about forty-five paintings, but then, I am an epic overachiever. It is nice to have a bunch cut up and ready to go because you will want to quickly shift between paintings.

2 Having a "frame" inside your paper helps to organize your composition. I consider this step essential. Create a 4" x 4" (10 x 10 cm) border within your 5" x 5" (12.5 x 12.5 cm) page. I used a 6H pencil (a pencil with a very hard graphite that leaves a faint, thin mark). For speed, cut a 4" x 4" (10 x 10 cm) template out of card stock and trace it instead of having to measure out a 4" x 4" (10 x 10 cm) window.

MINI MONO TIPS

- **When it's good to be all thumbs.** Artists frequently make something called "thumbnails" when they're figuring out the composition for a larger work. The size of a thumbnail will vary, but (incongruously) it's usually bigger than an actual thumbnail, ranging from 1 to 4 inches (2.5 to 10 cm). You can literally do a thumbnail on the back of a napkin. This is supposed to be a fast visual of a simple composition or concept. Here's my page of thumbnails for this project. It's a great, low-stakes way to get a bunch of ideas onto paper.

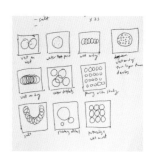

- **Circles everywhere.** To get your circle templates, you can use one of those architectural drafting circle stencils, which I used for some of the drawings, and you can also find all sorts of round things around your house, such as a quarter, a penny, a cup, the lid of something, a roll of tape, etc. I also used several round punches in various dimensions (card stock makes the best material for tracing).

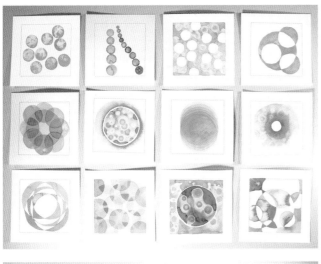

3 Trace circles of various sizes from various sources. Use your thumbnails for reference and generate different compositional ideas, patterns, and arrangements. Paint your circles using a single color of watercolor paint (this is called "monochromatic"). I used brushes in multiple sizes for versatility.

4 You will develop your own working rhythm, but for me it was helpful to work fairly rapidly. I can tend to overwork something, but if I have ten small paintings on my table simultaneously, it helps me to leave well enough alone (a big challenge for me).

5 Looking back, my favorite paintings are the ones I initially considered too minimal and intended to add more stuff—but didn't because I was too busy working with other paintings.

TO TAPE OR NOT TO TAPE?

I chose not to tape my watercolor paper for this project. I wanted the flexibility to shuffle the paintings around and have a lot of work in progress at the same time. As a result, my paper warped a little. Not too bad, but it's there. If you want to help your paper stay flat, you can tape it with painter's tape—tape all sides.

A FEW WATERCOLOR TECHNIQUES

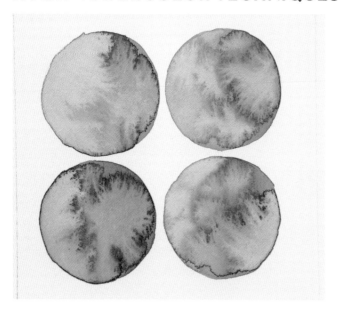

Wet on Wet

Wet on Dry

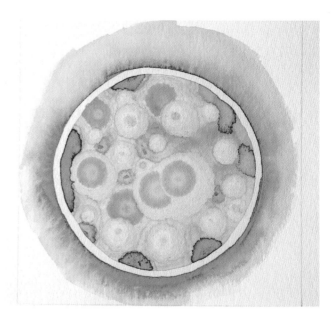

Salt. Sprinkle basic table salt on medium-damp paint. Set aside and wait. I've discovered this technique takes a long time to dry, longer than you'd think. If you try to brush the salt off before it is truly dry, you'll have a bit of a mess.

Rubbing alcohol (isopropyl alcohol). Alcohol and water don't mix, and this incompatibility can result in amazing effects. There are two ways to do it: use a small brush dipped in alcohol, then drop the alcohol into damp paint; or drop rubbing alcohol onto blank paper, let it dry for a few seconds, and paint color over it.

Flow: Not Just for Hippies

When I was going through the terrible, horrible, no good, very bad time, I experienced extraordinary, transcendent moments. Right smack-dab in the middle of crying all day and not sleeping or breathing much. These extraordinary moments actually happened quite a lot, sometimes while receiving support from loved ones, sometimes in nature, and significantly, often while I was making art. When I was immersed in color and pattern, I would come home to myself. I could breathe again. It was like I had a moment on an island in a choppy sea. The effect was so powerful, like an altered state caused by a psychotropic drug or alcohol, but, happily, with a painting at the end rather than a headache.

My curiosity about this experience led me to read about the science of flow. Flow, in a nutshell, is a state of active, intense concentration. Everyone has experienced it at one time or another—it's the experience where you suddenly realize that you haven't gotten up from your desk in four hours, and you're thirsty and you have to pee. Basically, it's getting so immersed in a focused activity that all other bids for your attention are totally muted. Including the need to pee. Time can take on weird dimensions—hours can pass but feel like mere moments, or a single moment can elongate into multiple decision points, such as a snowboarder executing a complicated move.

Given that this fairly broad term could have many interpretations, it would be easy to think that flow isn't a *sciencey* kind of thing . . . but it is. In the formal scientific literature, "flow" is studied by psychologists, occupational therapists, neural biologists, creativity researchers, efficiency experts, the military (I know, weird), elite athletes, and the list goes on. There are measurable biochemical changes in the brain and body. Performance is elevated. Get this: Getting into a flow state is an effective treatment for post-traumatic stress disorder (ptsd).

Flow is known to be a very pleasurable experience that furthermore produces enhanced performance. Flow-inducing experiences vary from individual to individual, but we're all wired to experience it. Like many people, I feel flow when I'm in a creative endeavor. Other flow triggers are team sports, meditation, cooking, performing music, being in sync with a group while working on a complex task, surfing, video games—the list goes on. Whatever you consider your flow triggers, painting can be a flow gateway drug—it's an easy entry point and a way to get your brain chemistry on board.

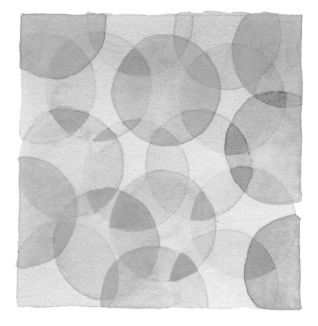

Collage Rainbow Wheel

We've taken an academic look at the color wheel, and now we're going to make one. Kind of. The color wheel is the old standby, and every school child is an expert. I taught a college-level painting class where I had the students do a "Free Will Color Wheel," by which I meant as long as they mixed pure, color-wheel colors, they could paint them in any arrangement they fancied. I explained a little about the history of the color wheel—my main man Sir Isaac Newton invented it. At the age of twenty-three, while being cloistered in his house to avoid the plague, as one does in 1665, he messed around with prisms and, being a physics genius, established the basis of what we understand as primary colors, roy g biv, and how colors interact with light, turning Plato's earlier musings (and the basis for all color theory for two thousand years) on its head. Charmingly, he also thought the color wheel was cor-related to musical notes, though he was never able to get his analogy to make perfect scientific sense. In the end, it seems, that particular notion was more poetry than science. In any case, he did understand that color existed in clear light, and he sketched the first ever wheel (with musical notes).

Anyway, there was an older guy in my class—and when I say older, I mean, like, in his eighties. The university offered free tuition to people over seventy-five. I suspected this gentle-man had a few pulls from the scotch glass before the eve-ning class most nights, as did I (um, jk). Whatever the reason, he always appeared to be having a good time. Come review time for the Free Will Color Wheel project, he presented a straightforward, classic, by-the-book color wheel. No frills. As explanation, he announced emphatically, "If Sir Isaac Newton says a wheel, *I paint a wheel*." Indeed.

I see your wheel, sir, and I raise you. That said, rules, schmules. Let's have some fun with this wheel!

SKILL LEVEL
Beginner and up

SKILLS LEARNED
Basic color sourcing and organizing

MATERIALS
Glossy magazines with high-quality
 paper
Scissors
18" x 24" (45.5 x 61 cm) mixed-media
 paper
Glue stick

MESS LEVEL
Moderate but not permanent

TIME TO COMPLETE
60+ minutes

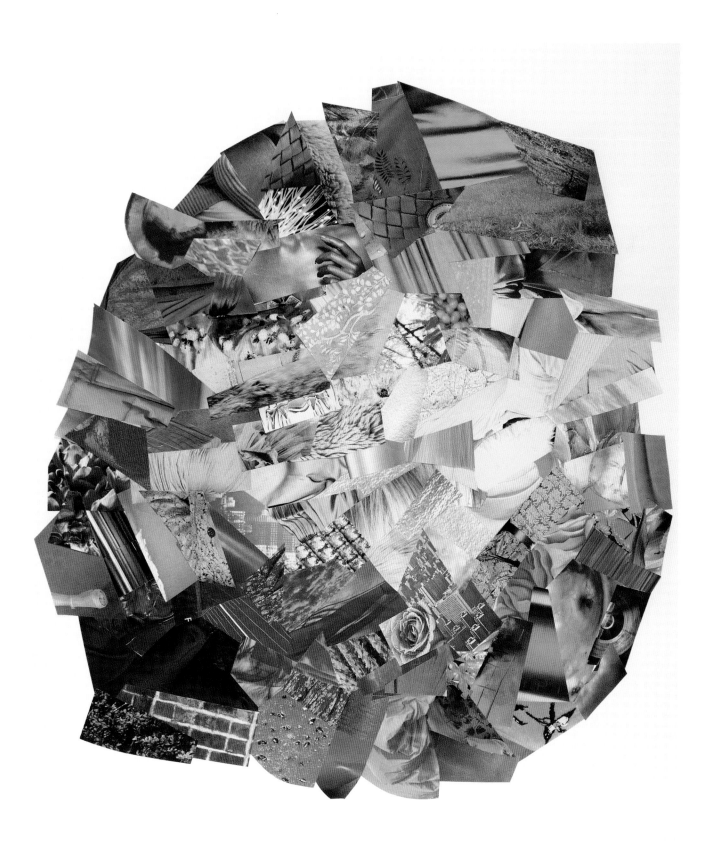

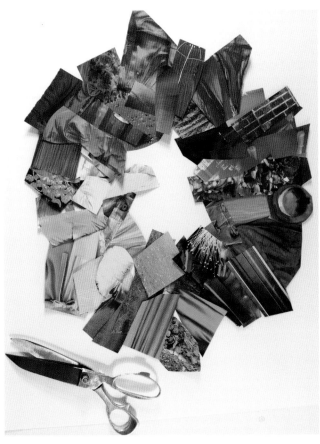

1 Start with color hunting. It takes a little while to train yourself to see the color and not the photograph of the handbag or whatever, so sometimes it helps to read the magazine upside down. Look for basic color-wheel colors on this project: red, orange, yellow, blue, green, and purple with in-between colors like turquoise and buttercream. You're looking for vibrant colors that may have some value shifts, slight variations, tertiary colors, and texture variety. Don't try to tell a story with words and pictures. Try to create a *sensation* with dynamic color.

2 When you've assembled a nice collection of the colors, glue them down on all-purpose art paper (show here, 18" x 24" [45.5 x 61 cm]). I often cut them to suit the shape and size I'm after, but since you layer them, you don't need a perfect fit. To get the paper to glue down flat, it helps to fully smear the glue on the paper and then press firmly starting from the middle and moving out, pushing out the bubbles. I overlapped the paper quite a bit.

3 I grouped the colors lighter in value toward the middle and did not make a perfect circle. You can keep adding more paper bits to various sections until you're satisfied with the overall effect. The idea is to make the colors appear to blend into one another. When in doubt, cut the bigger chunks into smaller pieces.

CONTENT QUALITY

You'll need a few magazines for this. I used about six fashion magazines and a couple of old *National Geographic*s to do the project in this book. You'll want high-quality magazines. The paper should be glossy and have a heft to it, not too thin like those weekly gossip magazines.

Don't use recognizable items or text. Focus on the color only. It's easy to let content and recognizable forms become a part of your collage, but that will take away from the heart of this exercise, which is playing with how various colors interact in their purest state.

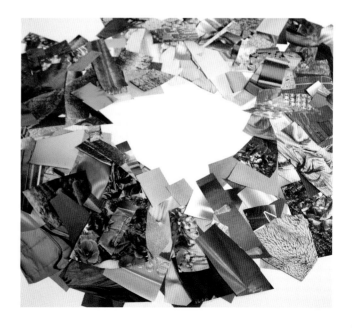

The Classic Schmear

Ah, the schmear. This is really where it all comes together for me. Mixing delicious piles of paint and creating tonal and value shifts, globbing different colors in a line, and smushing them together has got to be the ultimate satisfaction exercise. There are tons of ways to go about this, but the classic rainbow approach is a great starter.

A note on the rainbow: You absolutely can take the acrylic tube colors right out of the tube and schmear them all over the place. That is a legitimate approach, and if the spirit leads you, I wouldn't try to talk you out of it. But the thing about rainbows, really good rainbows, is that sometimes you need to tweak those tube colors. The tube colors are usually intensely pigmented (a sign of better-quality paint), and thus so concentrated as to be difficult to fully see. So I add white to almost every acrylic color. Also, my gradient obsession is to try to create a little hint of value shift in the color-wheel colors—the deep blue transitions to baby blue before it shifts to aqua. This just happens to be my jam in rainbow, but there are many, many ways to approach the rainbow—and to kill the schmear.

SKILL LEVEL
Beginner rainbow to advanced spectrum

SKILLS LEARNED
Navigating tube paint colors; creating color and value shifts

MATERIALS
Acrylic paints (5 + colors plus white, listed opposite)
Palette knife
Disposable palette
8.5" x 11" (90 lb. (165 g/m²) paper
Computer paper or scratch paper for the schmear instrument

MESS LEVEL
There might be paint on your undies after this project, so use caution

TIME TO COMPLETE
30–40 minutes for mixing; 30 seconds for schmear

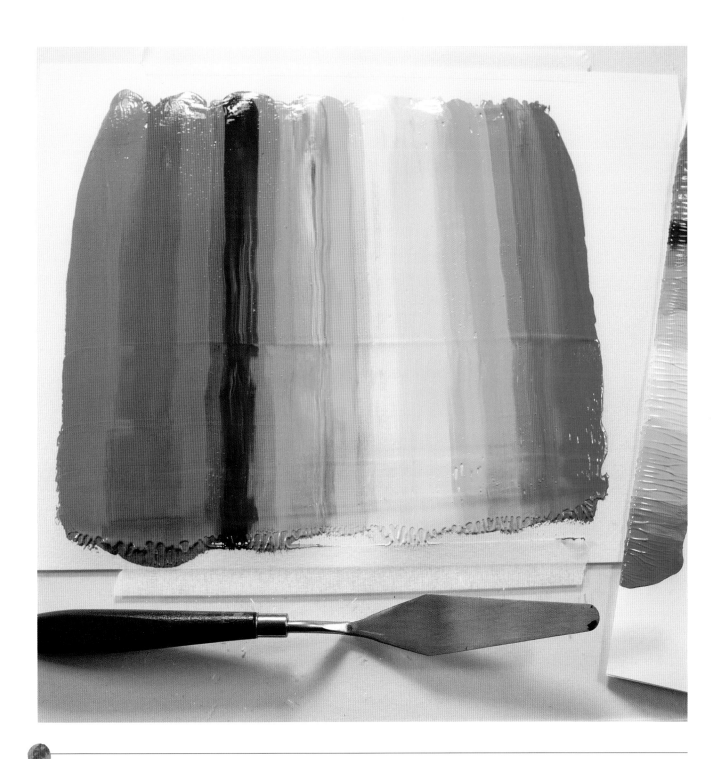

CHOOSING COLORS

I started with deep blue, turquoise, lemon yellow, magenta/crimson, and purple.

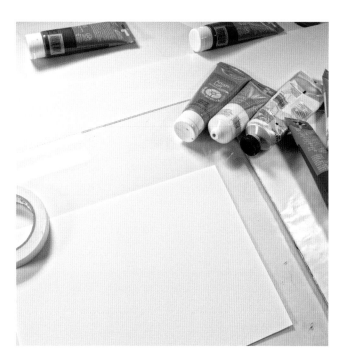
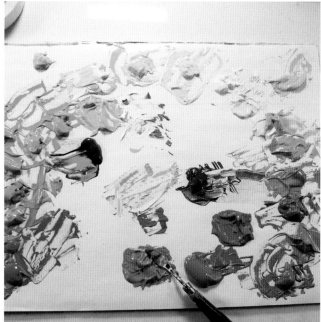

1 Prep your paper. Tape the top and bottom edge with a bit of masking tape. Use an underlying surface you don't mind getting paint on, because you will.

2 Using a disposable palette, mix the paint colors first. Squeeze out the paint in a half circle in that order. Use The Mother Method (see page 13) on mixing. This basically means you have a "mother" on your palette—a color you've mixed by which you draw from to guide the development of your whole painting. In this case, starting on one end of your palette, mix a desired blue by adding a bit of white. When you have a good amount of a blue that you like, scoop most of it over, setting aside a teaspoon or so for later use. Taking that mixed blue, you will add a little turquoise (and/or white) to create another pile of paint. Leave a little and move on. By transitioning directly from the previous mix, you will be able to achieve a spectacular rainbow ombré.

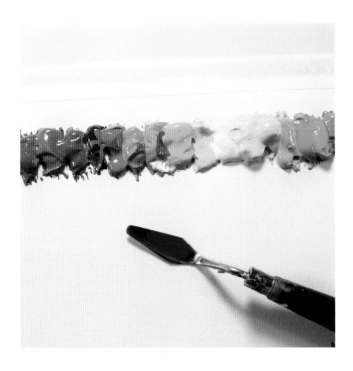

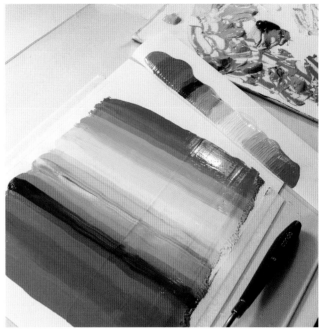

3 When you have your whole rainbow mixed—I mixed about twenty different colors across the spectrum—use the palette knife to plop/glob/galoop your paint on your page in a nice line. You want to make sure to put a good amount of paint here so that it will spread nicely across the page.

4 Fold a piece of computer paper into fourths (the long way). When you are ready—and you may have to do some meditation exercises and use calming breaths to handle the outrageous excitement—use both hands and the folded computer paper (which should be an inch or two wider than the line of paint) and with fingers spread out to provide even pressure, schmear the paint. You can make multiples passes if you wish. phew. There's nothing like it. Congratulations.

MAKING MULTIPLES

You can do this project nonrainbow style by which you use any colors you desire. In fact, you'll likely have excess paint, so I'd advise being prepared to do multiple schmears. It's the mixing that takes the most time, but the schmears themselves are quick.

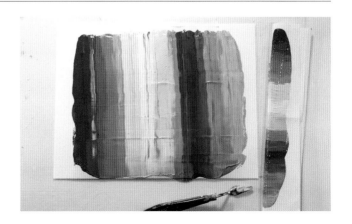

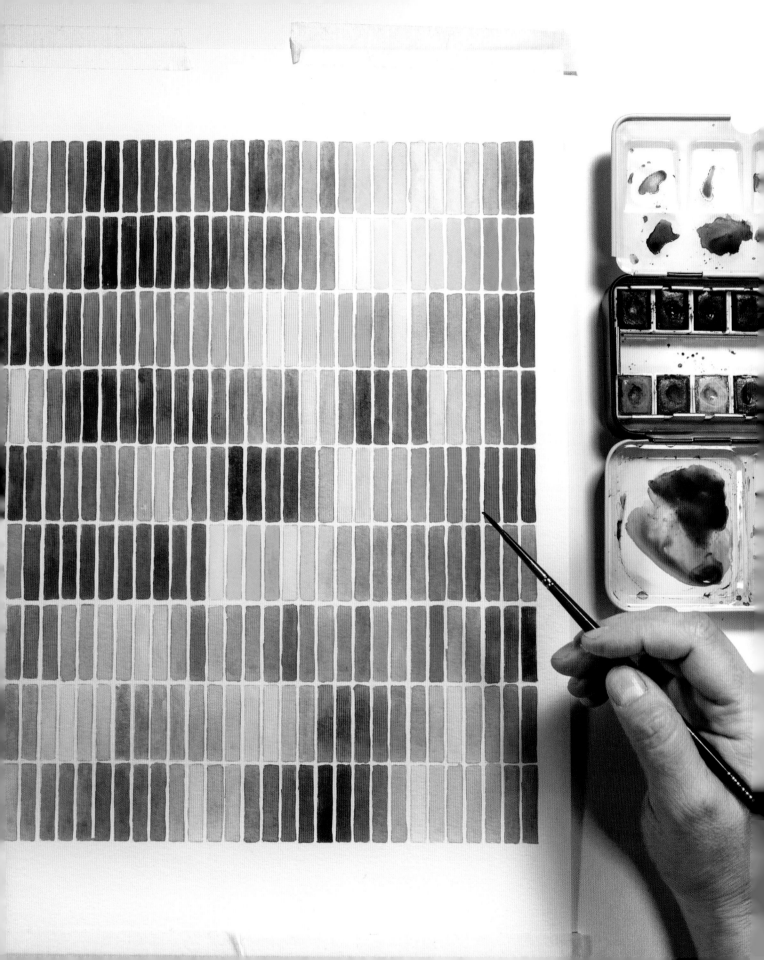

Flow Neuroscience: Turning Off

Flow is effective because it deactivates parts of the brain. This may sound alarming, but it's actually amazing.

A very important part of the brain is the prefrontal cortex. The prefrontal cortex is called the "executive," in charge of higher functions such as planning, judgment, self-awareness, and social moderation. You'd think you'd need that for creative work, but what's interesting is that getting into a flow state actually slows down the function of the prefrontal cortex. The state is called transient hypofrontality, which simply means the functions of the prefrontal cortex are diminished temporarily. Self-awareness is reduced, time takes on weird dimensions, and the ticker tape of to-do lists, judgments, and opinions are downgraded to background noise, or complete silence. Being in flow is a lot like having an out-of-self experience. And let me tell you folks, I reeeeeeeaaaaallllly appreciate getting a break from myself. Sometimes my internal self is worse than a whiny four-year-old.

A person in flow even experiences physiological changes: She breathes more slowly, and her heart rate and blood pressure drops. Another thing that happens is that the major facial muscles relax. We've seen this when a concert pianist is so involved in her performance that her face makes weird expressions as she plays. Because flow has taken over, she is fully connected to the music and not concerned at all about how her face looks to other people. This is the job of the prefrontal cortex, and it's temporarily off-line.

In transient hypofrontality, our brains become more flexible and "loose." A person who regularly experiences flow is usually more creative and adaptable across all activities. Because creativity is sometimes defined as something that is novel and useful, we need our brains to be very flexible when we are solving a creative problem. By the way, creativity doesn't just include art! Your creative problem could include a design problem, a parenting issue, a physician trying to diagnose a tricky illness, a new route to work because your usual way is blocked, a fresh communication technique when the old ones aren't working, etc. This is why people frequently report thinking of the key to a complicated problem while they are doing something unrelated, like driving or jogging. In flow, our minds are free to roam. The internal judger is turned off and new solutions appear, as if out of nowhere.

Value Gradient Primer

Master watercolorist Edward Hopper (1882–1967) was called "the painter of light." Seeing his watercolors in person, I made a careful inspection to see exactly how he was so masterfully painting light. As it turns out, the lightest bits in his paintings were actually just bare naked paper. He wasn't painting light at all—he was leaving it alone. A more apt description was that he knew what colors to paint *around* the light to make it really pop and glow, and had the presence of mind and discipline to leave some areas alone.

Important and sometimes not-understood tip: Do not use "white" with watercolor. You get white, or lighter colors, by adding clear water and diluting the color by utilizing the white of the paper. You *can* buy white watercolor, but if you use it, please be forewarned: It will be like muddy, flat chalk with no luminosity. Like Dracula's skin. Like the back of my knee in January. Like grass that is trying to grow under a rock. For almost exactly the same reason, I do not use black with my watercolor kit. Black will also be flat, dead, and opaque. Dracula again. And coal. And mud. I will say more about how to darken your colors without using black paint in later projects, but don't worry, you'll be fine.

This project is twofold—it's a great way to explore the pure, unmixed colors on your palette while learning how to introduce water to create a value gradient (darker to lighter).

SKILL LEVEL
Beginner

SKILLS LEARNED
Exploring your colors; using water to change value

MATERIALS
Templates:
- Value Gradient Primer, page 139 (shown on pages 46–47)
- Value Gradient Primer: Variation, page 140 (shown on pages 48–49)

12-color watercolor kit (see page 19)
#4 round brush
Paper towel

MESS LEVEL
Minimal

TIME TO COMPLETE
30 minutes

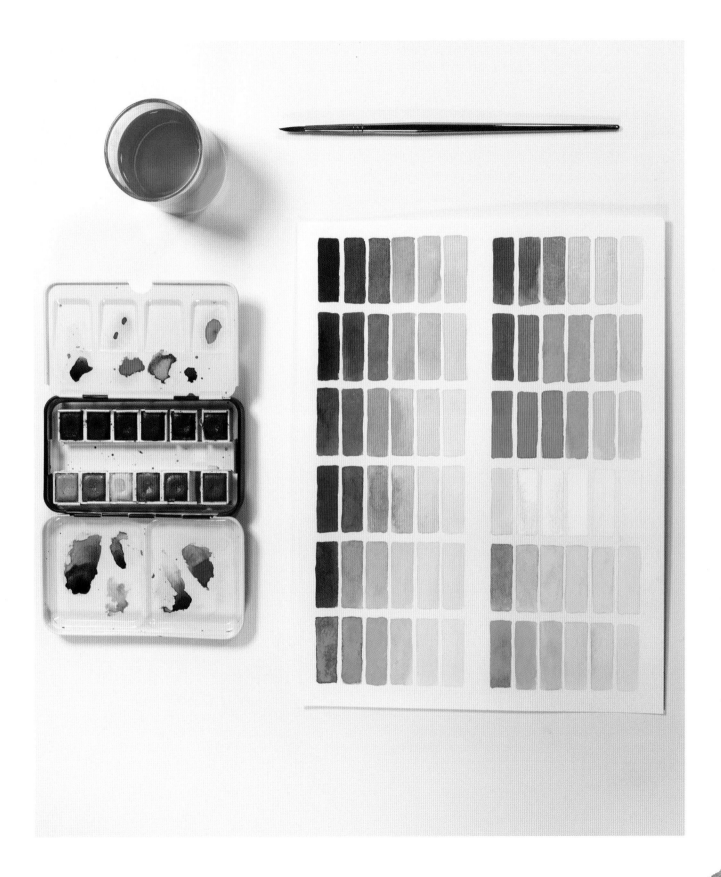

1 Use the provided template (see page 139) or create your own.

2 To keep everything from running together, you must have channels/moats in between your swatch colors. Consider this essential. The goal here is to create the truest, unmixed tones of your watercolor pans. Your palette, your paints, and your water need to be clean and untainted by other colors or you will not get a pure color. In between colors, dab up the previous mix on your paint palette with a paper towel so that there's no chance of contamination.

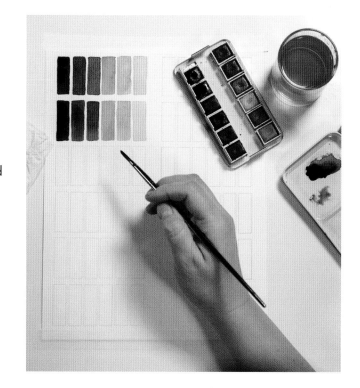

3 Start by using your brush to add water to your pan of color. Using a few brush loads of water, really squish that brush around in there for a while, like ten seconds. I used a #4 brush for this painting. The goal is to get superconcentrated paint load on the brush for the first, darkest swatch.

4 Paint the first, darkest swatch. After you add the dark paint to the template, don't wash your brush! Using the same paint load, spread that paint on a clean and dry spot in your mixing palette. Do a flash dip in the water—just collecting a bit more water but not washing the brush. Mix this water to the color already on your palette, and add this slightly more watery color to the next spot on the swatch. Add more color from the damp half-pan.

5 It is difficult to see the true color on your mixing palette. Test your color on a blotter, and when the value is slightly lighter than the first swatch, add the next swatch! And repeat. I use The Mother Method (see page 13) because a single color remains on your paint tray, always informing the next value gradient. You don't have to mix up a completely new color.

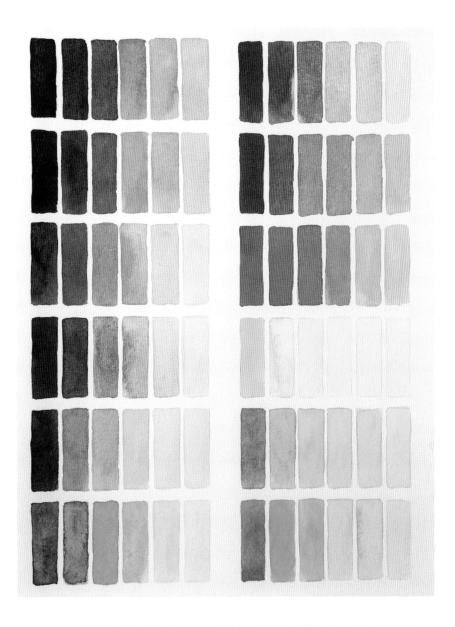

VALUE GRADIENT PRIMER TIPS

- **Start over.** If you think the value shift is too dark or too light on your painting, you can dab the paint while it's still wet with a dry paper towel. Wet, freshly applied watercolor will be removed quite well and you can start over.

- **No more buckles.** I tape down at least two edges of my paintings. Otherwise the edges tend to curl up and the paper buckles.

VARIATION: GRADIENT BARS

Using the Gradient Primer as a jumping-off point, this project uses all of the blending techniques: across the wheel, around the wheel, and up and down value—*at the same time.*

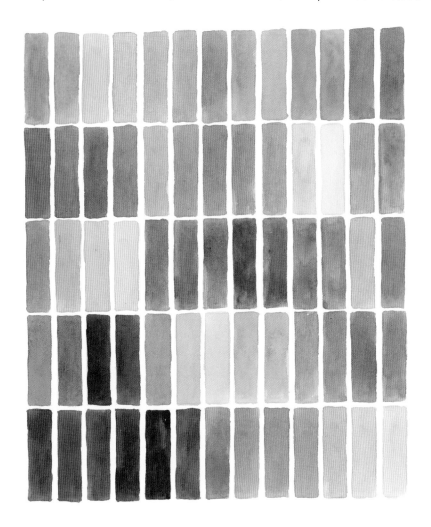

LIMIT YOUR PALETTE

For this variation, I limited my palette to four colors: phthalo blue green, lemon yellow, quinacridone coral, and a tiny bit of imperial purple because it can help to narrow the options a bit.

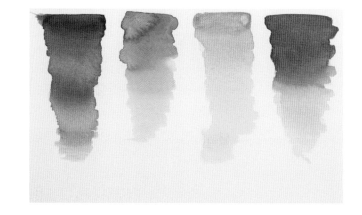

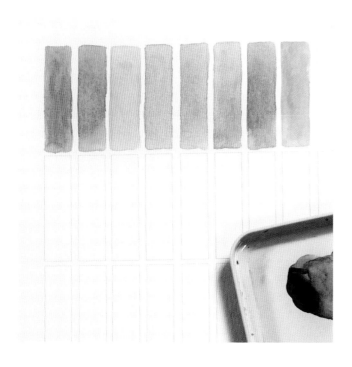
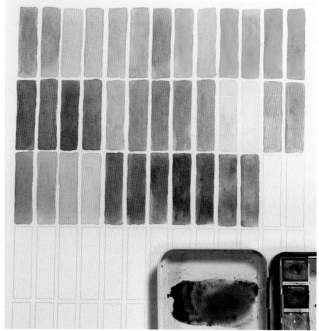

1 Paint the first swatch and work across the page, lightening the color with water until you feel the time is right for a color/value shift. I started from the top left and worked across the page, just like reading a book.

2 Following The Mother Method (see page 13), use the previous color still mixed on your palette. Add a speck of either water or color to subtly alter the earlier color. Or both if you want to get real crazy!

3 If you can get the color *and* the value to shift in a natural way, you are a watercolor master.

EMBRACE THE GRAY AREAS

When you mix two colors that are complementary (positioned across the color wheel from each other), you'll find that they create various shades of grays or neutrals. It's the balance of grays, neutrals, light and dark tones, along with pockets of vibrancy, that will make your composition sing. Don't be afraid to mix up various grays. They are usually my favorite colors and will likely create overall harmony.

Tri Me

Value is one of those tricky art terms that doesn't have anything to do with how much something costs. Value has to do with light, specifically, quantities of light and dark in a color. The more white or lightness in a color, the lighter the value. If black is added to a color, the value will usually be darker. However, a color that is heavily saturated with intense chroma can have a darker perceptual value than a muted color. Up and down value is the third technique of color mixing that I use, but value can sometimes be tricky to actually see, especially when you are looking at different colors with different levels of saturation. When you're learning how to differentiate value, it's sometimes helpful to work with a monochromatic color range, meaning one color, because it simplifies the process. I used red, but any color will work.

SKILL LEVEL
Beginner

SKILLS EXPLORED
Collage; monochromatic color; value

MATERIALS
Crafting card stock
Triangle punch
11" x 14" (28 x 35.5 cm) mixed-media
 paper
Glue stick

MESS LEVEL
Don't work around a ceiling fan. Or
 blow-dry your hair nearby.

TIME TO COMPLETE
30–60 minutes

LET YOUR CAMERA HELP

Now that we live in the age of having sophisticated cameras at hand, a quick way to determine value is to take a photo and desaturate it in your phone's photo-editing software. Then you can easily see what is darker or lighter.

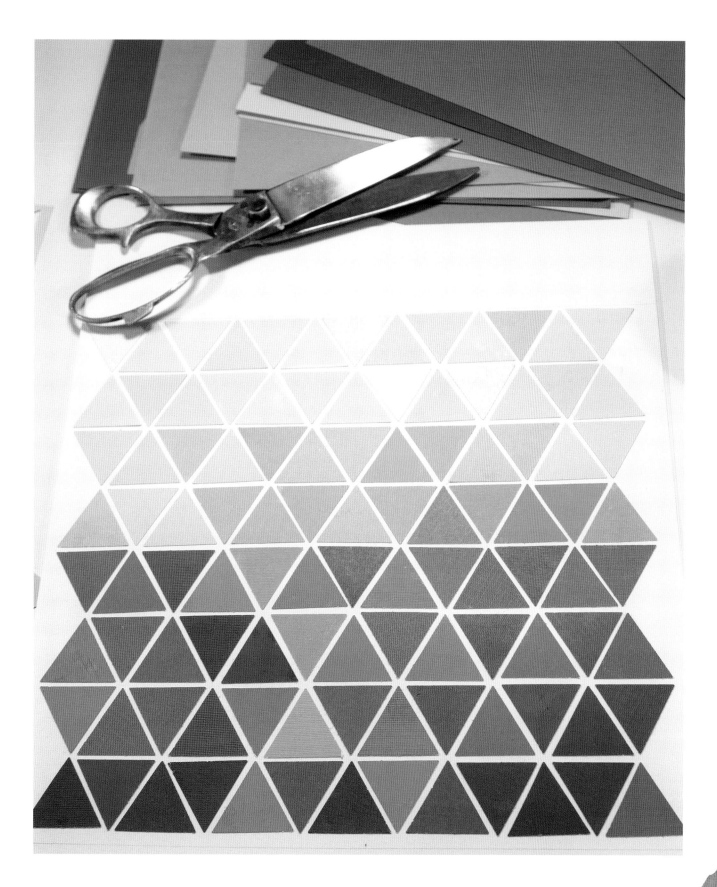

1 Assemble your color range in some sort of color organization. This project is not *strictly* following the rules of monochromatic, as you can see that I was trending toward tertiary colors on either side of red on the color wheel (purpleish and orangeish). This subtle range creates temperature changes. Red is commonly regarded as a warm color, but when it trends toward purple it's cooler, and likewise warmer as it moves toward orange. Making slight temperature shifts within a single color makes for complex and sophisticated visual interest.

2 For this project, I punched out about 120 triangles and used 11" x 14" (28 x 35.5 cm) mixed-media paper as a support. Once you have your shapes cut out, you can loosely organize them according to their value range.

3 These triangles are placed with a narrow channel or moat in between the shapes instead of being butted up against one another. I usually apply the glue to the substrate rather than the triangles, but if things get messy, it can help to put the glue right on the collage element. In either case, please expect that your fingers will get real sticky.

Loose Brain Mojo

The number one thing that people say when I tell them I'm an artist is: "Oh, I'm not creative. I can't even draw a stick figure." People are intrigued and fascinated by the artist life, but also a little defensive, as if they are uncomfortable because of their (perceived) lack of creativity.

Let me be real honest with you: This attitude drives me crazy. First of all, creativity is the force that propels the universe. Look at nature. Everything, at every moment, is begetting and begetting. Bees do it, flowers do it, rocks do it (verrrrrry slowly), stars do it, atoms do it. Everything is trying to make order out of chaos; everything is trying to make something from nothing. Every human is born creative, creativity pouring off them, dripping from their soul.

Creativity can be broadly defined as something novel and useful. For the love of Mike, it is not limited to the fine arts! Research shows that developing creativity in one area opens up the brain to be more creative in other areas. Unfortunately, creativity tends to be applied only to a very small population of people who perform music, are eccentrically flamboyant, or happen to have paint on their hands.

Intelligence relates to organizing what is already known and having a controlled, dense, and categorical system of knowledge. An intelligent brain is a "tight" brain. Intelligence is convergent thinking, tending to follow well-established patterns. Paradoxically, creativity involves release. A creative brain is a loose brain, actively releasing the known solutions and allowing for the unknown. Creativity is divergent thinking, which—news flash—we need more of. Divergent thinking is "other" thinking. It takes a new path; it *forms* a new path. The intelligent brain will retain all the details and history and background of a problem. The creative brain will discover the new solutions that no one thought of yet. I'm not dissing intelligence; obviously, we need it! In fact, a genius is a person who is extremely strong in intelligence and creativity.

LOOK FOR STRIPES

In a more complicated collage, you can see the value shifts in mostly monochromatic stripes.

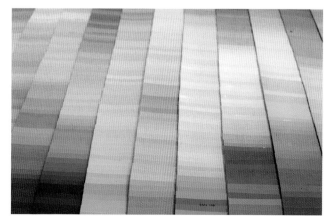

The Freud

You know those inkblot Rorschach tests they use to find out if you're crazy? I guess they're hoping you look at one and say, "It looks like my mother . . . and a *bear trap*," because then they'd know exactly what was wrong with you. Well, I don't know what Freud would think about the color version of the Rorschach. One thing is for sure: These images can be rather provocative. Certainly they evoke hips and, um, female anatomy. One observer, however, thought it looked like—and I quote—"Otters fighting." If I were a psychiatrist, I would screw in my monocle, scribble some notes, and say, "Hmm, fascinating; tell me more." My four-year-old daughter saw it and, without being prompted, immediately said, "Socks!" Not sure what *that* means, but she has been helping me match the socks when I do laundry, so maybe the forced child labor situation I have going on here (um, jk) is really getting into her blood.

The great thing about this project is that you can make something legitimately cool and all you have to do is mix up thick, gloopy batches of paint and squish them onto a page. I use the low-end acrylic paint for a project like this—the "student-grade" acrylics. You don't even need a paintbrush, but you do need a flexible small palette knife. You can use any kind of palette, but I prefer starting with a fresh sheet every time (disposable palette sheets) rather than cleaning a wooden or plastic palette.

SKILL LEVEL
Can you open and close a book?
 You're ready.

SKILLS LEARNED
Analogous color; acrylic paint mixing

MATERIALS
8.5" x 11" (21.5 x 28 cm) 90 lb. (165 g/m²) mixed-media paper (scored down the middle for easy folding)
Palette knife
Disposable palette
Acrylic paints in blue and magenta + white

MESS LEVEL
You know what they say about getting toothpaste back in the tube? It can't be done. Same goes for acrylic paint. Also, imagine taking a peanut butter and jelly sandwich and stomping on it. The jelly will go everywhere. This is a real risk with this project.

TIME TO COMPLETE
30–90 minutes

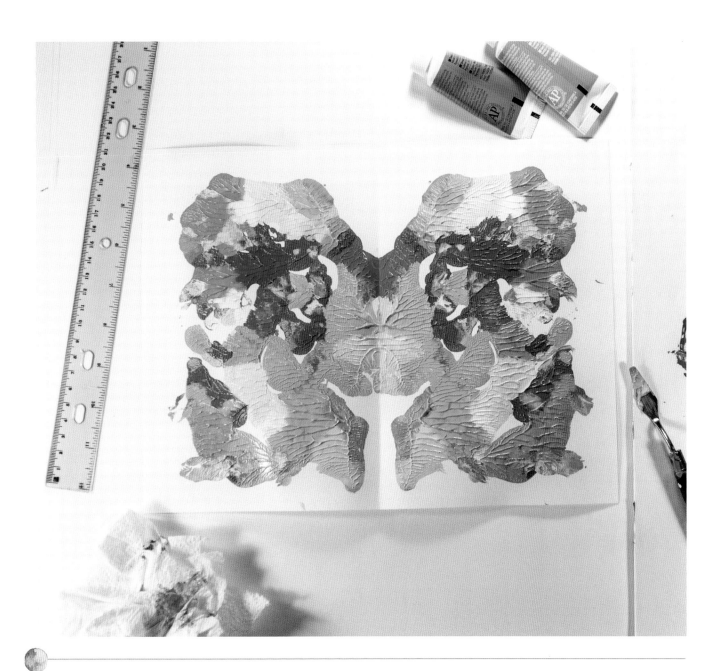

CHOOSING COLORS

I used fuchsia and robin's egg blue, which create lavender when mixed, so I ended up with an analogous color scheme. Other analogous combos are yellow/turquoise, crimson/yellow, and green/blue-purple. You can use literally any two colors, but if you choose a complementary pair, the two will combine to create various browns and taupes.

1 Prep some 9" x 12" (22.9 x 30.5 cm) 90 lb. (165 g/m²) general-purpose art paper by folding it in half. Heavier-weight paper will be hard to fold, but if the paper is any lighter, it won't hold up with the paint and becomes a wrinkly mess. Since the paper is moderately stiff, it helps to mark the center of the page lightly with a ruler and pencil, then use a hard edge to score the paper in a straight line. It will fold beautifully along that line. Fold it now so that you don't have to mess with trying to fold it when it's full of paint.

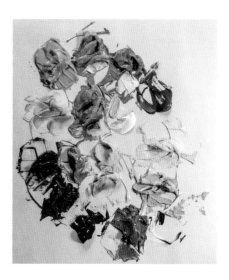

2 On a fresh palette, squeeze out healthy amounts of two colors plus white on either side of the page. I chose a fuchsia and robin's egg blue. Those two colors create lavender when mixed, so I was working with an analogous color scheme—when three colors neighbor one another on the color wheel. Make multiple blends, mixing these colors with white and with one another, preserving little piles of the various tones you are creating.

3 When you have a nice arrangement of mixed colors on your palette, don't stop! I mean, you literally can't, because if the paint dries, you have to start over. You have about 15–30 minutes of working time with acrylic. Using the palette knife, add some paint to one side of your unfolded sheet of paper, opened like a book. Leave some white space, but add little pockets of thick, impasto paint in various places (impasto paint looks a lot like dabs of buttercream frosting). Leave an inch (2.5 cm) or so around the outside edge.

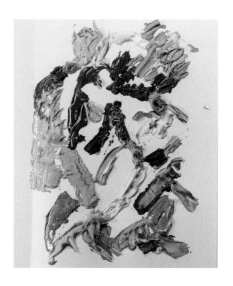

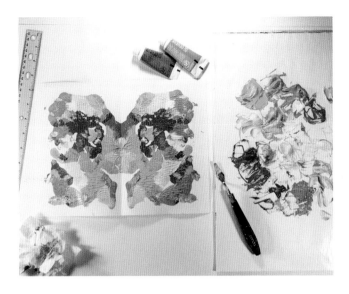

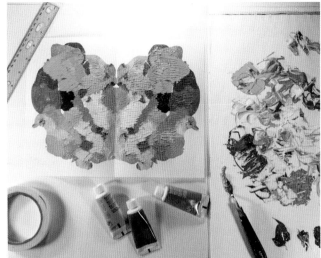

4 Now comes the fun part: Fold the two sides together. Carefully press down, guiding your fingers inward (you don't want to press the paint out between the paper, like too much peanut butter on a sandwich). Make sure all points of the folded pages have made contact. When you're ready, carefully pull pages apart for the big reveal.

5 You'll probably have some paint left over. Make a few more! I added more colors and made another.

6 Bring your painting to your psychologist and ask her to interpret. She will probably say, "Socks!"

NO IRON NEEDED

To get Freud paintings to dry flat, lay them out on a flat surface and add a little tape to the corners.

What Happens If

It's sometimes helpful to head into a project expecting that you'll throw most of it away. In the end you may not want to, but it's helpful to take the pressure off. Hmm, don't like how that one turned out? No problem—toss it. My psychologist friend talks about the value of approaching your life like a video game. No, not vaporizing the rude clerk at the grocery store with your Gandalf wand, but treating the challenges that come your way like "levels." What's the best way to "win" when you're dealing with rude people? Probably not vaporizing them. Kill them with kindness? Ignore and smile? For sure winning would be not letting it ruin your day or making you behave rudely. If you can solve this challenge, you move on to the next level! And we all know, video games don't really matter. Stop taking yourself so seriously.

SKILL LEVEL
Beginner

SKILLS LEARNED
Banishing perfectionism

MATERIALS
12-color watercolor kit (see page 19)
#4 round brush
Paper towel
140 lb. (300 g/m²) watercolor paper
 cut in 3" (7.5 cm) square swatches

MESS LEVEL
Minimal

TIME TO COMPLETE
30 seconds and up

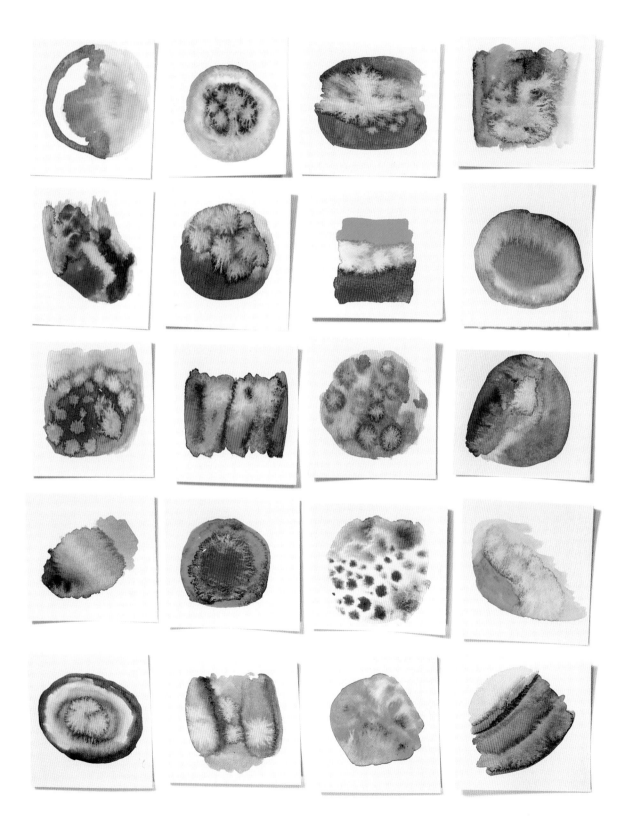

1 You can do this all on one sheet if cutting isn't your thing. I like to work on many 3" x 3" (7.5 x 7.5 cm) swatches so that I can move around quickly. To begin, ask yourself: What happens if _____? (Examples: What happens if I try to make a beautiful one? What happens if I try to make an ugly one? What happens if I make a superpink one?) Then try it.

2 Give yourself 30-90 seconds for each swatch. Set it aside and move on quickly. You're just figuring out how this video game works; you have a lot of spare lives. There's no money or blood riding on this. Or even ego, because no one will see it after you throw it away (probably)!

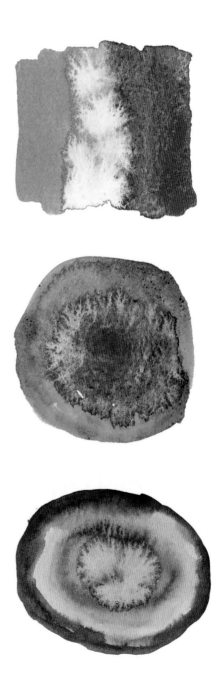

3 This project benefits from painting fast and furious but with limited colors. The more colors you add, the better your chances are of a muddy mess. For most swatches I used two colors. But since this is the new analog game of What Happens If, feel free to go crazy, as in, "What Happens If I Add *All the Colors*?"

(p.s.: If you decide to keep your swatches, they will come in handy for the Bring Out Your Dead project; see page 70.)

Opposite and below are some of the questions I asked, and the "answers."

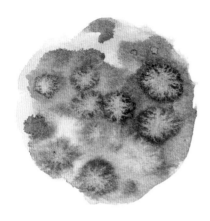

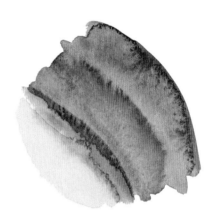

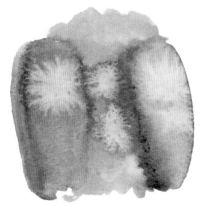

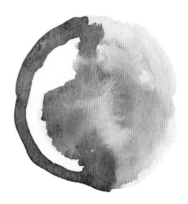

GIVE IT A HOT SECOND

Watercolor can change dramatically from wet to dry, so don't cash in your chips because you don't like it right away. It might dry into something amazing.

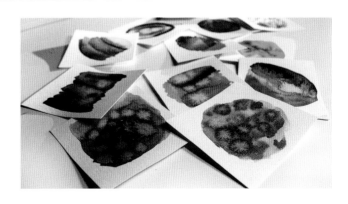

Whipped Rainbow

I call this Whipped Rainbow because there's something particularly edible about using the paint in this fashion. It reminds me of making meringue and getting those luscious soft peaks out of the eggs. (That was that one time I baked back in '95. It was great.) Still, I'd strongly advise against eating any of this project. Do not eat your paint. I'm pretty sure, however, that you can transfer these skills directly to cake decorating. So if you want to include your portfolio shots of your Whipped Rainbow work along with your bakery job application, I would recommend it. As you would expect, cake frosting color-mixing ratios are strongly correlated to actual paint. For instance, a friend was trying to mix purple frosting with red and blue food coloring and failed miserably. Mixing colors is never as simple as one part blue, one part red. Nope. In the case of purple—notoriously tricky—it's more like five parts red and one part blue. For frosting or acrylic paint. Stay tuned for more handy baking tips.

SKILL LEVEL
Beginner to moderate

SKILLS LEARNED
Palette knife black belt award

MATERIALS
15" x 15" (38 x 38 cm) prestretched primed canvas
6 acrylic tube colors + white
Palette knife

MESS LEVEL
Maybe I'm unusual, but when I use acrylic, my hands always look like I've been attacked by live fireworks dipped in liquid Skittles. So yeah, it's messy.

TIME TO COMPLETE
1–2 hours

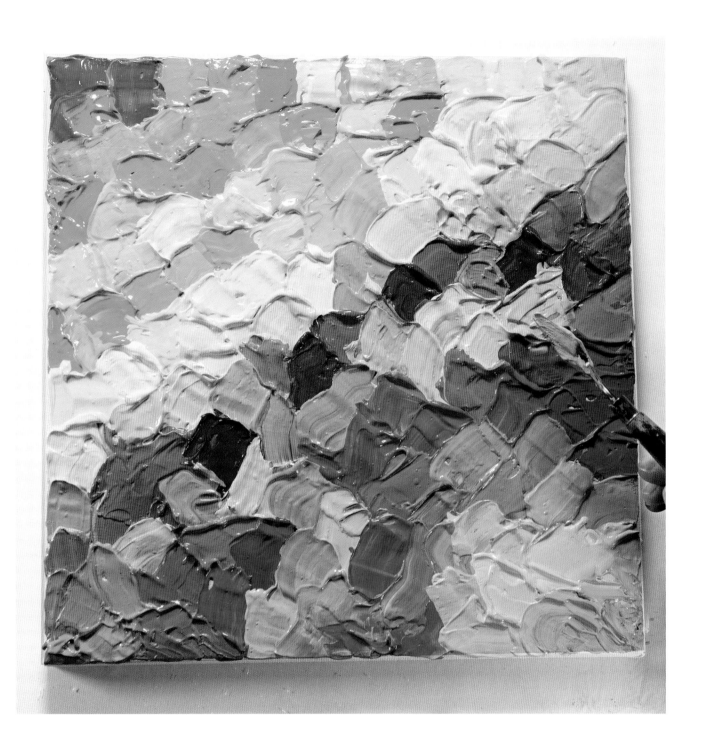

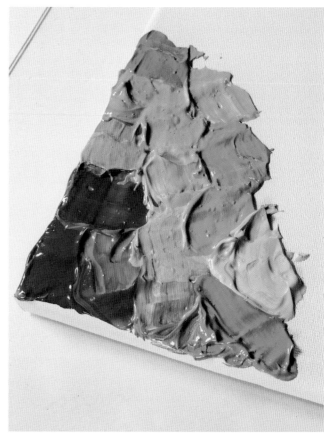

1 Mix your colors on the palette using The Mother Method (see The Classic Schmear, page 38). After mixing each color, immediately apply it to the premade canvas using the palette knife. Following The Mother Method, make sure you preserve some of that first mix to use for the next color to create the color shift.

2 This is another painting that will benefit from not overworking. After you mix the right color on the palette, carefully lay it down with your knife in an area roughly the size of a square inch (2.5 cm), and move on.

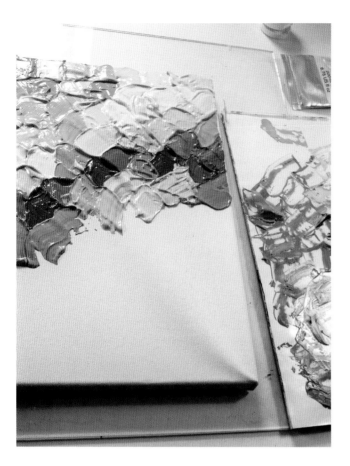

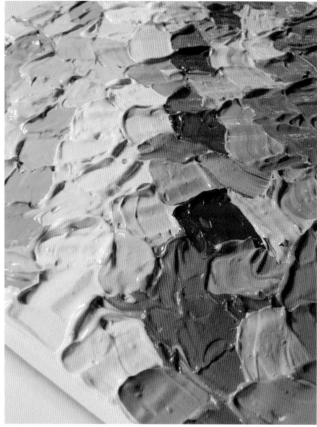

3 I started with the top left because, being right-handed, I tend to drag my knuckles across the top of the painting, and if there's wet paint there, you can imagine the result.

4 I didn't particularly plan my color approach, but you can sketch out your plan with pencil if you wish.

LEAVE THE BLOBS ALONE

Keep a fresh paper towel nearby to wipe your palette knife as you work. Once you lay down your blobs, don't go back! It will be very difficult to alter or fix the paint you've already laid down when it's wet. You will be able to rework it quite easily, however, once the painting is dry.

Q*bert

When I was making this painting, I was like, Wow, I'm really feeling all neon tube socks and Hula-Hoops and George Michael suddenly. *What's happening to me?* Then it came to me: I'm just getting pulled back to my roots. My Q*bert roots. If you have no idea what I'm talking about, please know that there was a pretty cool video game in the '80s called Q*bert, where a little orange guy would jump around on a pyramid of colored cubes and the colors of the platform would change as he jumped. Take my word for it, it was rad.

SKILL LEVEL
Beginner

SKILLS LEARNED
Getting a 3-D effect

MATERIALS
Template: page 141
12-color watercolor kit (see page 19)
#2 and #4 round brushes
Paper towel

MESS LEVEL
Minimal

TIME TO COMPLETE
60 minutes

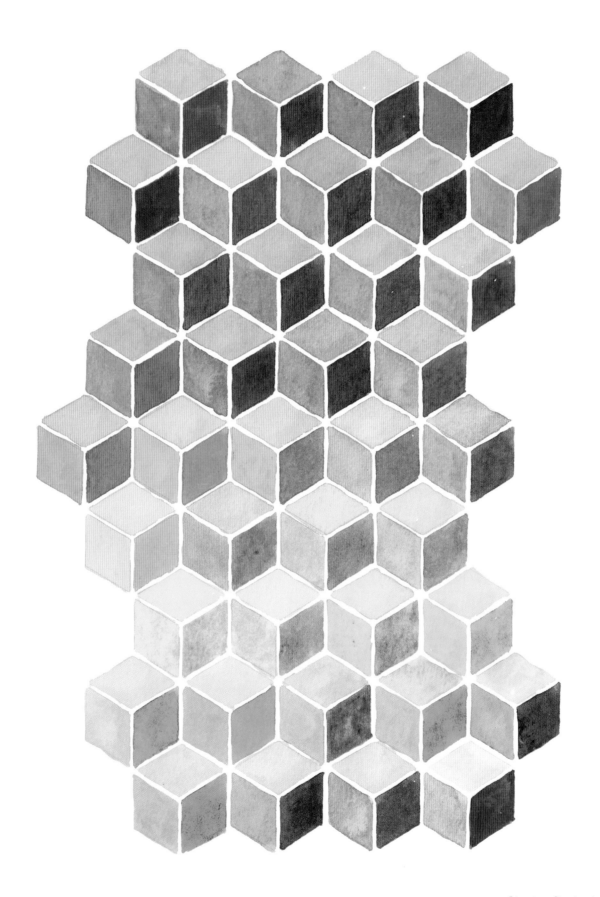

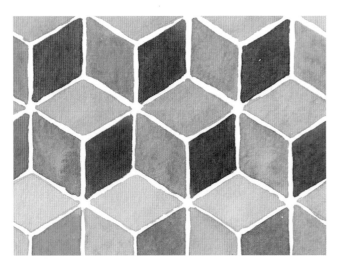

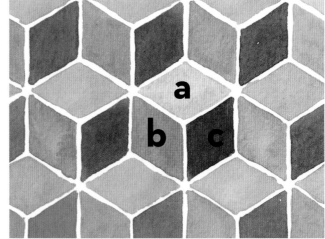

1 We're going to continue utilizing The Mother Method (see page 13) here while transitioning value and shifting color around the wheel. This pattern, common in tile, is assembled simply out of diamonds, which for some reason for me was a revelation when I finally understood what was going on. This design has the sweet capability of adding some 3-D effects. If you want to create the illusion of depth, you need to think about how your value range is being utilized.

2 In this design there are groups of three diamonds that make up a hexagon. Each panel of the hexagon needs to be distinctly different in value. I started with the darkest, most concentrated value (c), added a bit of water and went onto the medium range (b), and finished with the lightest section (a).

3 You can plan out your colors in advance. There are about forty cubes in the Q*bert template. If you want to work with the whole spectrum, that means about six to seven cubes per color group (based on a six-color wheel). You can mark small notations on each section using a 6H pencil (it leaves a very faint mark) to indicate where you want your colors to go as a guide while you're painting. If I don't keep track, I lose my head and paint everything pink.

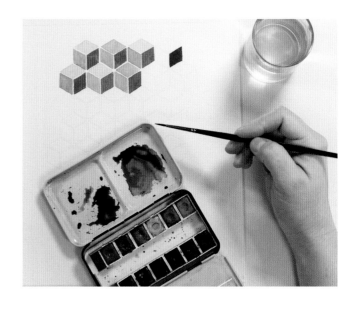

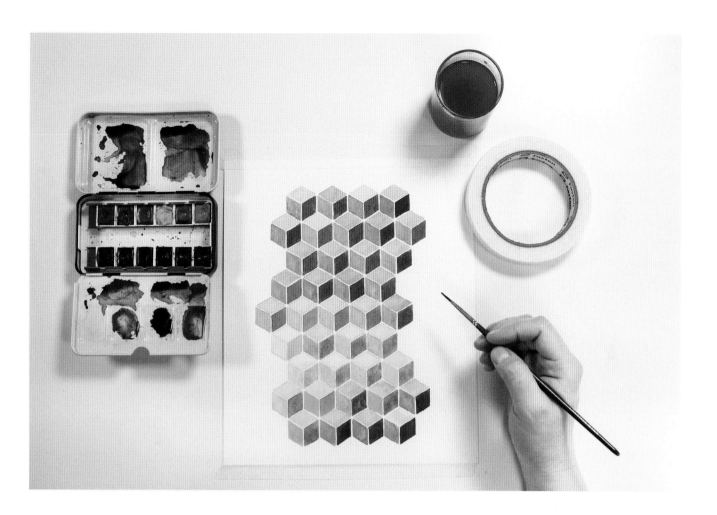

Failure

Do you realize that another phrase for "experiment" is "multiple failure"? Failure is 100 percent essential to the creative life. Failure is 100 percent essential to a fully lived human life. I really believe perfectionism might be the biggest enemy to human joy. The compulsion to get it right all the time = ego! The compulsion to be well regarded by others = ego! Perfectionism is also probably the biggest enemy to good art. All the artists I know who are making anything interesting have made a ton of things that aren't interesting. Seriously, "talent" doesn't have that much to do with it. Persistence is more like it. Endurance. Consistency. As Benjamin Franklin said (or possibly it was just my friend's dad): "The harder I work, the luckier I get."

People who are regarded as geniuses in their fields, statistically speaking, don't just simply have a few really good ideas; they have hundreds and hundreds of ideas, and one or two of them turns out to be astonishing. Live boldly. You don't have to exactly revel in your failures, but don't regard your failures as a sign you're doing something wrong. Regard your failures as signposts that you are making your path.

Bring Out Your Dead

Nothing is ever wasted. You loved someone and it didn't work out? Don't worry, that love is still alive and vital and ready to be passed on to the next recipient. You put your heart into a project and didn't get a good result? Don't worry, all that energy is boomeranging back to you in a different form. Something was taken from you? Some injustice was done to you? There was betrayal, loss, judgment, pain, and malice? Like a living thing, put that energy on the altar of the world. Offer it up, knowing that letting go of the sorrow will create room in your heart for the real. Bring your sorrow to the light; let it be exposed and vulnerable and wilted and beautiful. It's like you're at church and the usher is bringing around the basket. But instead of a wrinkled and damp five-dollar bill, you put in your worst pain. The Mother World will take the pain, and cherish it, and bring you something throbbing with life and sweetness in return.

Embracing failure is one of the best gifts you can give yourself. Sometimes you bury your failures and they never see the light of day, which is a perfectly legitimate choice. Sometimes you put your failures in a box. A literal box, not the metaphorical church basket. I like to call this box my "Used Paper Box." Friends, it's overflowing. For this project, we're going to bring out the failures. It's like the scene in *Monty Python*: "Bring out your dead!" If you have no idea what I'm talking about, please enter that phrase in your YouTube search box and watch the two-minute video. Consider yourself educated in old-school comedy gold. You're welcome.

SKILL LEVEL
Beginner

SKILLS LEARNED
Recycling

MATERIALS USED
Watercolor paper
Glue stick
Scissors
Various punches
11" x 14" (28 x 35.5 cm) mixed-media
 paper

MESS LEVEL
Moderate

TIME TO COMPLETE
One never knows

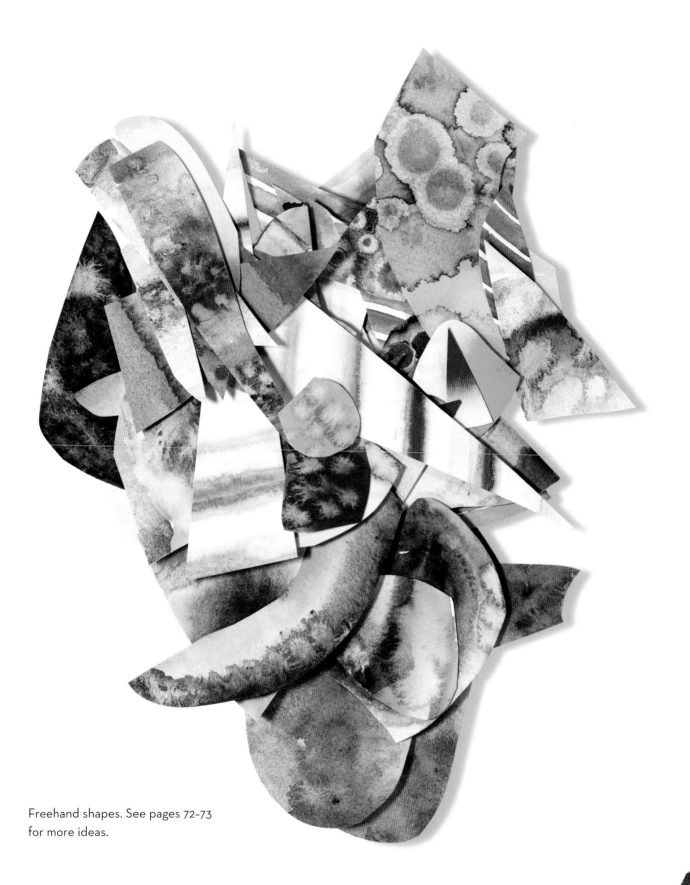

Freehand shapes. See pages 72–73
for more ideas.

1 First, you need to paint a lot so that you can create a lot of failures so that you have abundant materials for this project. #winning! Or you can just mess around and experiment with paint on paper to generate materials. But that's the cheater's way.

2 Grab your box of not-so-good paintings. Prep scissors, punch, glue, and mixed-media paper.

3 Depending on your resources of failed paintings, you should be able to make a few collages. I recommend working on several at once. I like to lay things out (prior to gluing) and then change them as I go. It helps me to have fresh eyes. Some things to experiment with:

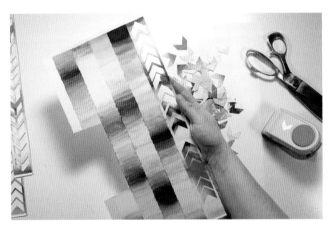

Repetitive shapes made by the punches

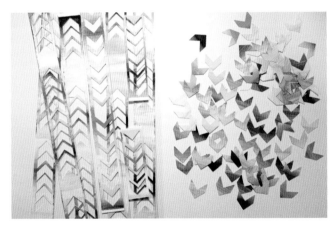

Negative spaces

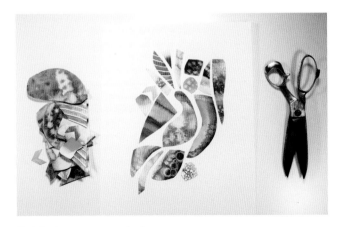

Pointed versus rounded

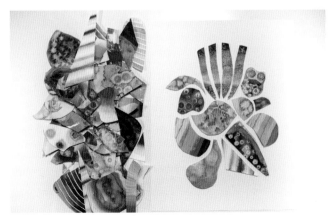

Delicate versus chunky

Loose paint style versus rigid geometric cutting

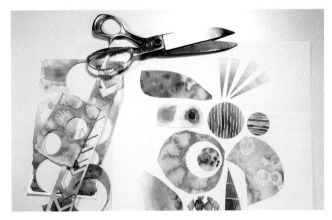

Value and color contrasts

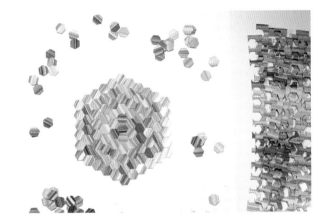

Repeating motifs

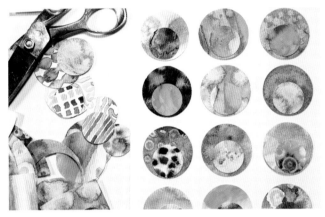

Layering

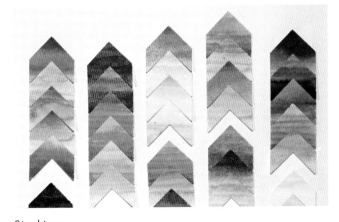

Stacking

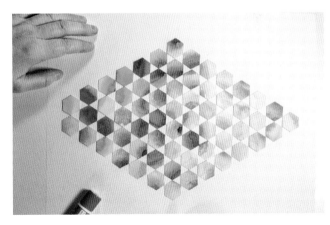

Geometry

4 I played around quite a bit before I glued anything down. My advice is try different things and don't be committed to any one course of action. The discovery process of upturning the failures into a new language is refreshing. New ideas will certainly be born.

Dots

I love color charts and paint swatching. I rarely do things like follow systematic, organized rules when I execute a color chart (I mean, that's asking a lot), but I love them all the same.

In this color chart, I actually followed the rules of all sensible, methodical color charting. And let me just say that painting a legit color chart is hard. There are a lot of balls, er, dots in the air, a lot of paint flying around the palette, and it is very difficult to moderate the color and value of your swatches. That said, doing a proper color chart is one of the best (only?) ways to learn mad mixing skilz. What will perhaps feel like suffering in the short term will pay off in extravagant dividends in later paintings.

SKILL LEVEL
Moderate, but helpful for beginners to gain skills

SKILLS LEARNED
Basic paint blending in watercolor

MATERIALS
Template: page 142
12-color watercolor kit (see page 19)
#4 round brush
Paper towel

MESS LEVEL
Minimal

TIME TO COMPLETE
60 minutes

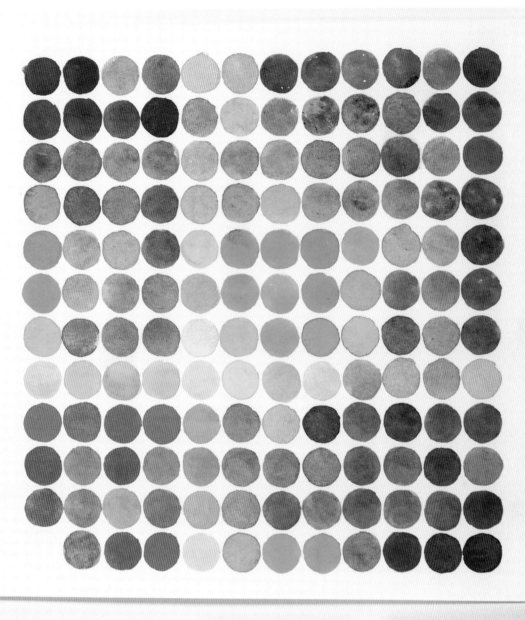

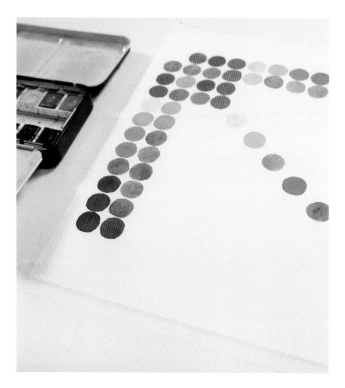

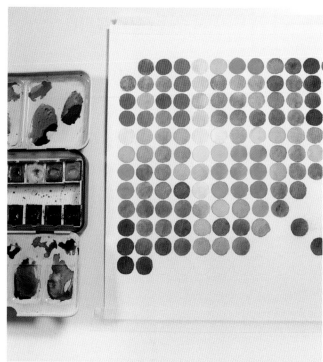

1 This style of chart works something like an Excel spreadsheet. Basically, there are rows and columns. At the intersection of, say, column 7 (yellow-green) and row 3 (quinacridone coral), you will see an example of those two colors mixed.

2 This chart requires strong, clean palette discipline just like the Value Gradient Primer project (see page 44). Keep a roll of paper towels handy to clean up the wet paint on the mixing area from time to time to keep your mixes as pure as possible.

3 You'll also have to consider the ratio of each color when blending. You'll find that as far as mixing paint goes, blue, purple, and red are extremely staining and powerful. If you are mixing yellow with any other color, it's not as simple as a one-to-one ratio. It's more like ten-to-one (favoring yellow). With a red-blue mix, you're going to want to see purple, but you'll need a five-to-one mix (favoring red). Different brands and hues of paints have different staining power, so a big part of this is experimentation.

Art Scars

By third grade, many people have received what social psychologist and author Brené Brown calls "Art Scars." Often in school, many kids receive a shame-based message that they are not, and could never be, creative. This is usually when the "talented" kids are shuffled off to the advanced art or music rooms. The Art Scar goes deep, completely inhibiting people's freedom to explore their own creative abilities. Instead of the extravagant joy and exploration of the uninhibited first grader, the third grader starts to apply self-judgment, comparison, and perfectionism to the art practice. Activate prefrontal cortex! Eliminate flow! (By the way, while I don't have many art scars due to my unschooling in the woods by artist hippies, I absolutely do have volleyball scars. Major issues there.)

Some of the projects in this book may appear to be too simple. Have you ever heard someone look at a piece of art and say, "My kid could do that"? Well, since the people carrying Art Scars were probably kids when they got them, I say let's start at the source of the harm: third grade! Let's start making projects that a third grader would love! And then if you want to go on to paint the *Mona Lisa*, go forth—no one is stopping you!

In the scientific literature, the experts have concluded that for people to enter a flow state of transient hypofrontality (flow), they must be engaged in an activity with 4 percent difficulty. I think this is hilarious, because how do you ever quantify 4 percent difficulty? What if your activity trends toward 7 percent? Or 3 percent? But, the point is this: You want to exercise a skill that you feel you can master, but not one that is so easy that you are bored. I think it's interesting and revealing that the number is 4 percent. I would have guessed 25 percent or even 30 percent. It's encouraging to know that we only need to dial up the difficulty to 4 percent. Probably the reason a lot of people quit trying to gain a new skill is that they start at 40 percent instead of 4 percent and the result is frustration, sulking, quitting, etc. And/or breaking their leg because they are trying to learn to snowboard. Or getting crushed by the mean girls spiking volleyballs. Hypothetically, that could totally happen, too.

When I teach art classes, I've observed that most of the projects in this book hit the sweet spot of 4 percent for most people across many skill levels, for novice artists or professionals. I'm not sure why this is, because working with colors and shapes seems to be almost childishly elemental, and yet the vast array of color combinations, surface treatments, and design possibilities keeps it firmly engaging.

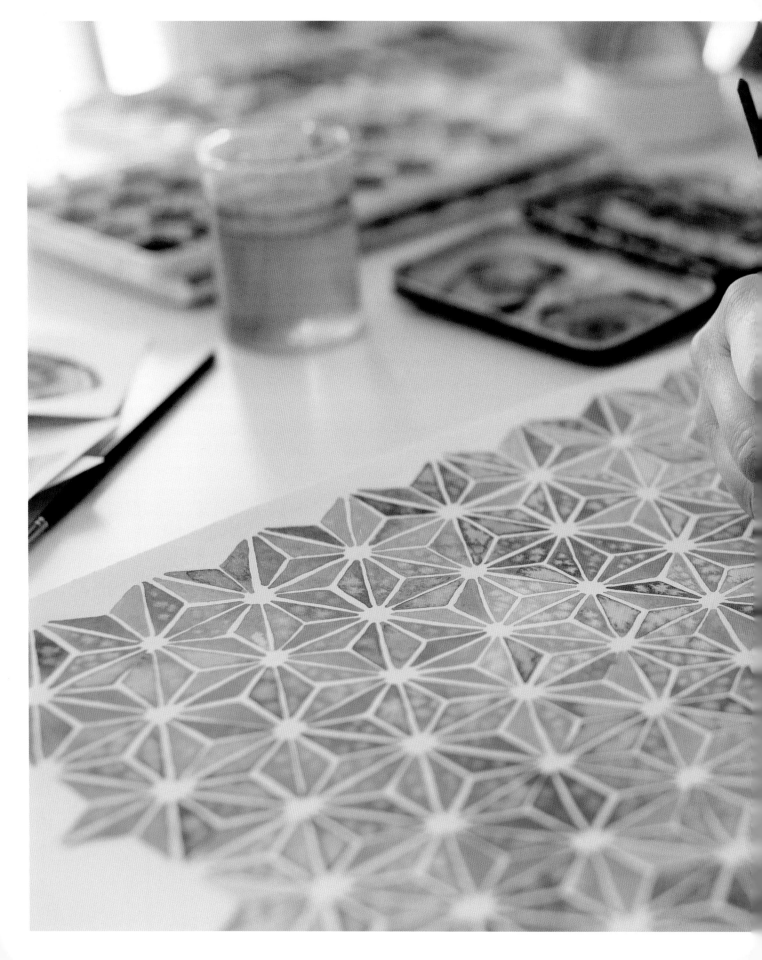

2
Next Step Projects

Chevron Spectrum

Working with the full spectrum in highly saturated colors is one of the more enjoyable activities. This project fits into the Around the Wheel category introduced on page 12. There are literally a million variations of this project, but the thing to know is that you don't want to use browns, grays, taupes, or neutral. No siree-bob. Brights, we want brights.

Let's get science-y for a second. Your eye sees all of the things like, say, a glorious insane rainbow circus and all its components, but your brain blends colors together subconsciously to make it easier for your conscious brain to concentrate on getting tacos. This process is called *gestalt,* which is the German word for the system your brain uses to process the crazy amount of visual data you are receiving at any single moment. Your brain does it really fast for survival purposes. Basically, you can't take forever identifying individual colors and a tree and your mother and a tiger that wants to eat you. You need to spot that stuff without even knowing your brain is at work because what you need to be doing, *obviously,* is finding tacos. Or pie.

SKILL LEVEL
Medium

SKILLS EXPLORED
Pointillism; ombré; chroma; saturation

MATERIALS
Crafter's card stock
Chevron punch
Glue stick
11" x 15" (28 x 38 cm) mixed-media
 paper

MESS LEVEL
Not too bad, but the chevrons can
 scatter in a light breeze

TIME TO COMPLETE
60–90 minutes

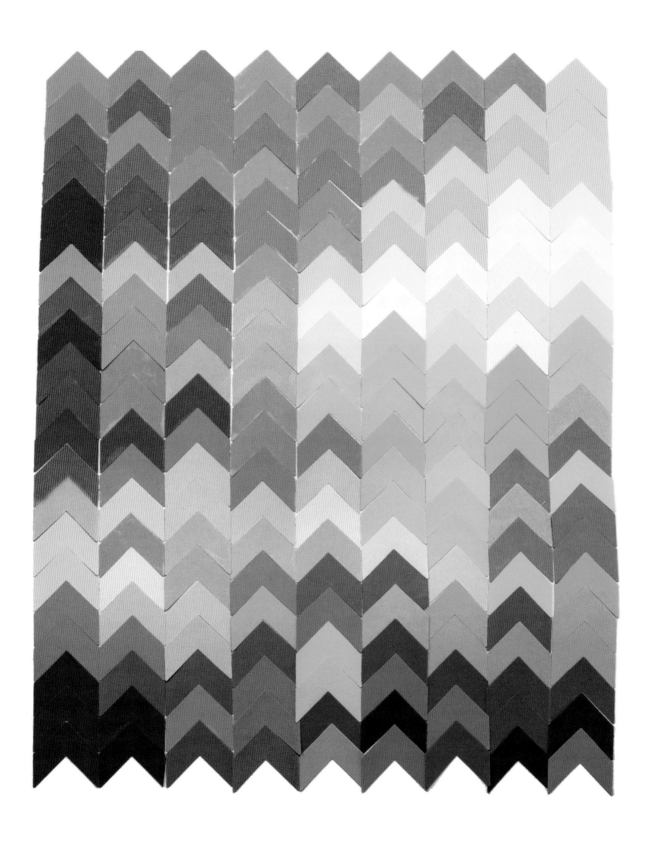

1 Assemble your collage material and support paper. Do all the punching first. Sometimes it's helpful to punch "upside down" so that you can see where your paper is positioned in the cutting element.

2 Once you have your shapes assembled, apply glue to the paper and begin. I started in the top left and worked down and across simultaneously. After I applied everything, I took a few moments to decide if there was any one color I didn't like. In a couple of instances I applied a new color right on top of the old one. Boom. Fixed.

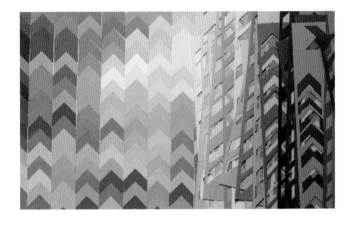

WHEN TO BE A HOARDER

I found the leftover chevron rainbow cuts were at least as beautiful as the finished collage. Not sure what I'm going to do with them, but I'll keep them around until inspiration strikes. I have a lot of left-over materials stashed for the future.

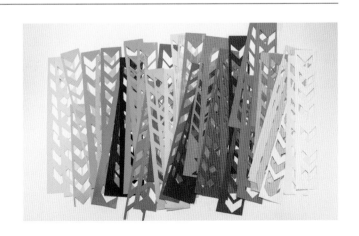

Talent Doesn't Exist

I don't believe in talent.

Before attending a concert featuring well-known twelve-string guitarist Leo Kottke, a friend of mine found herself in an elevator with the musician himself. She wistfully told him, "I wish I could play the guitar like you." He replied, Oh, you could. You just have to be a dorky, lonely teenager and sit alone in your bedroom for hours and weeks and months and years fiddling around with your guitar. You'll get just as good.

I don't think talent exists the way we usually think of it. Someone pops on the scene suddenly and is called an overnight success, but we don't see the fifteen years of prep, hard work, and ramen that went into that "overnight."

Here's my equation for success in almost any field:

10 parts hard work + 10 parts luck + 1 part innate ability = success

We would never tell a brain surgeon, "Wow, you are so talented at brain surgery." That's laughable. The reason the surgeon is good at her job is because she studied for years, sacrificed nights of sleep, and underwent an extremely rigorous gauntlet of training. None of us would sign up for brain surgery by a novice who had taken a human anatomy class and "showed promise." Sure, brain surgeons have a certain kind of aptitude, a mental ability to store a lot of data, a baseline of intelligence, and the means to pay for medical school. Those things amount to nothing if they didn't actually do the work.

Perhaps it would be more helpful to think of talent as a kind of aptitude. Shaq O'Neal happens to be seven feet tall, which probably helps his basketball career. Not all tall people have an aptitude for basketball, but most nba players are taller than average. So Shaq's height represents a kind of physical talent. He grew up in Newark with an incarcerated dad and a struggling single mom. He went to the gym to "get off the streets" and learned to play basketball. The circumstances of a difficult childhood actually funneled him into playing sports, and his natural aptitude (plus physical height) became a learned skill. And he got very, very good at it. I imagine if you asked him why he was good at basketball, he would point to all the hours he spent in the gym as a teenager.

I hear you saying, "But I don't have any aptitudes!" *Au contraire*, grasshopper. Some people are definitely wired for certain kinds of activities. I don't like cooking, but from what I hear, cooking is a flow trigger for a lot of people. This boggles my mind, but if you want to do something, guess what? That's evidence that you have an aptitude! I don't want to cook, or downhill ski, or play the kazoo: I probably do not have flow triggers in those areas. But there are other areas that spark me up! Don't let your lack of skill or experience hold you back from participating more with the things that capture your interest.

Waiting for the Diamonds

Watercolor can be fabulously luminous. I've heard it said that watercolor is like a veil of color draping on other colors. One way to work with watercolor's translucence is to work wet on dry, which means you have to wait for the lower layers to completely dry before you try adding the next layer.

Yes, you have to wait. In order to get the paint veil to settle nicely and not leak all over the place, you have to make sure your previous layers are very dry, completely dry, like bone dry, dry like the Sahara, dry like a fine sherry, dry like my wit. Get it? If it's not dry, it will bleed, and no one likes blood. Waiting is super annoying, so when I'm working wet on dry I will sometimes work with six simultaneous paintings so I can keeping going. Some people use a hair dryer to speed the drying process.

SKILL LEVEL
Moderate

SKILLS LEARNED
Working wet on dry

MATERIALS
Templates:
- Waiting for the Diamonds, page 143 (shown in project on pages 86–87)
- Waiting for the Diamonds: Triangle Variation, page 144 (shown on page 87)

12-color watercolor kit (see page 19) or watercolor ink
Palette with mixing wells
#2 and #4 round brushes
Paper towel

MESS LEVEL
Minimal

TIME TO COMPLETE
2–3 hours, but a lot of that's waiting

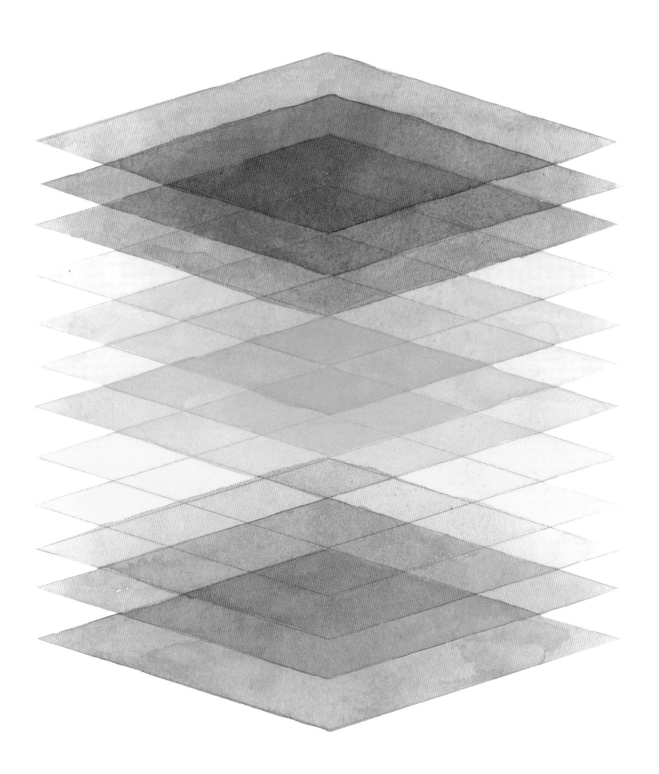

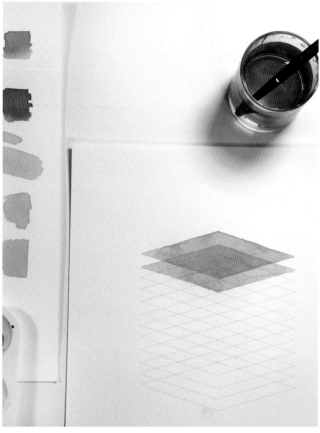

1 Use extremely diluted watercolor ink and little paint trays equipped with wells (kind of like a shallow egg carton). Add a tiny speck of the very concentrated watercolor ink and add water. You can also use paint from your watercolor pans diluted with water in the same fashion. It takes a while to get the color and shade right, so use a scrap page to test your colors.

2 It can be tricky to get the right level of transparency for the wet on dry layers and the rule of thumb is to start very light. Watercolor will dry darker than it looks wet on the page.

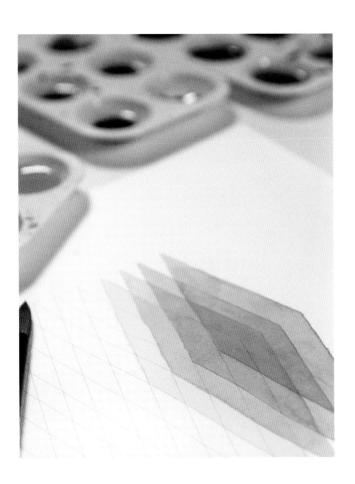

3 When you come back to add a new veil of color, use a light touch. The underlying area will "come up" if you work it too much, so you've got to get in and get out like a stealth bomber. Don't let the paint even know you're there.

TRIANGLES, OH MY

A great variation on diamonds is . . . triangles!

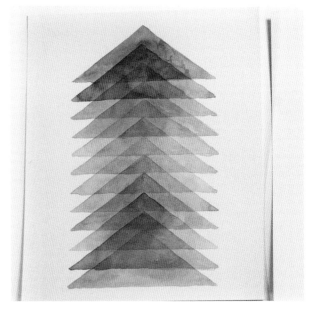

Flat Diamond

This is a progression from Tri Me (see page 50), a project where we examined a wide value range within one color root. It is deceptively hard to organize multiple colors in the same value range. This means that if you were looking at the colors in black and white, there would be little discernible difference in light or dark. We will pick one value and will try not to move up and down on the value scale, though the colors will shift around the wheel. Meanwhile, I would *never* encourage people to go to the big-box hardware stores and take free samples of paint chips and use them for a purpose for which they were not intended. Because that would be wrong. (Wink.) However, if the craft store card stock fails you by not providing the color range you need, pulling some of those paint chips that you've had saved in the back of the junk drawer might help the situation by adding more tonal variety. But you didn't hear it from me.

SKILL LEVEL
Medium

SKILLS LEARNED
Establishing a consistent value scale

MATERIALS
Crafter's card stock supplemented with paint chips
Triangle punch
18" x 24" (45.5 x 61 cm) mixed-media paper
Glue sticks

MESS LEVEL
Don't work on your open-air ocean patio during a hurricane

TIME TO COMPLETE
60 minutes

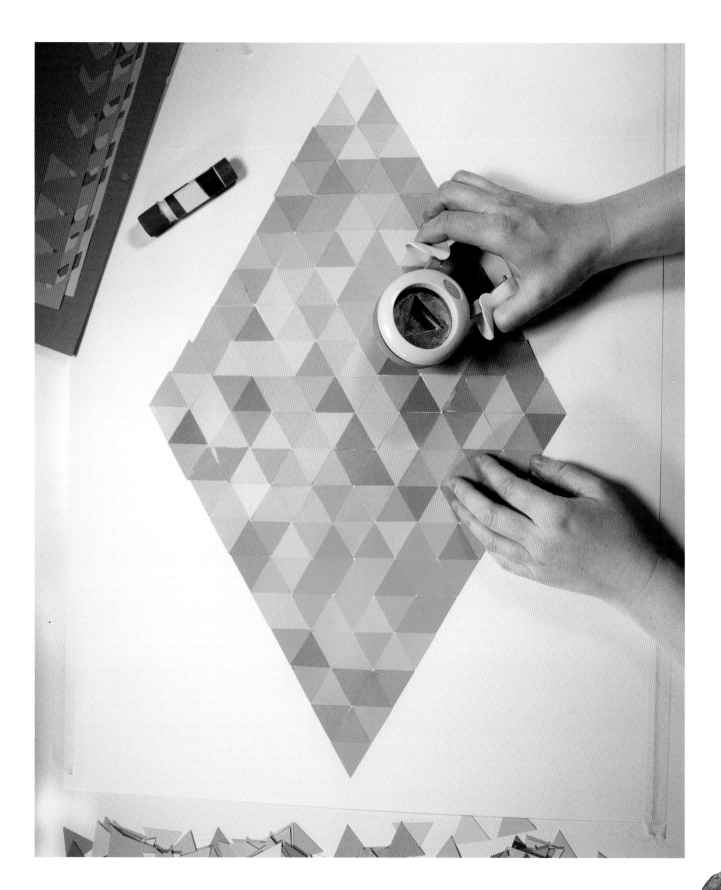

1 For this project it's helpful to have a wide variety of available colors (see note on paint chips on page 88). Assembling the colors is the hardest part. I stacked everything up and then went back and pulled out colors that snagged my eye. (Try the earlier phone camera desaturation trick (see page 50) here if you're having trouble.)

2 To make sure my diamond would fit on my paper, I established the middle point with a ruler (which will be the widest part of the triangle) and, using my 1-inch (2.5 cm) triangles as a guide, measured out to my starting point on the left (10 inches/25.4 cm). In this case, I punched the triangles out before I started.

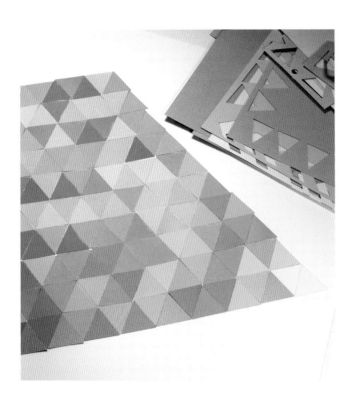

3 I glued the triangles down by putting a spot of glue stick on the triangles, not the support paper. It takes longer, but the glue stick can leave marks on the other colors. It is also messier for fingers, but it's worth it. Every time I do a collage, I realize toward the end that some of the colors aren't quite right. Rather than peeling them off and risk tearing the paper, I just add the correct color right on top.

LIGHT AND VALUE

Looking at these two desaturated images to the right, you can see that the diamond project is pretty much in the same value range, while below shows a wide range of light-to-dark shifts.

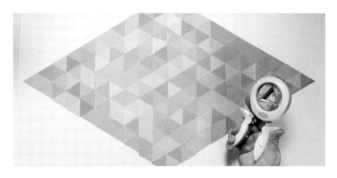

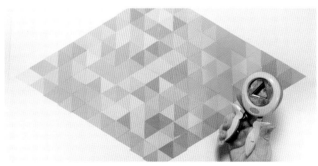

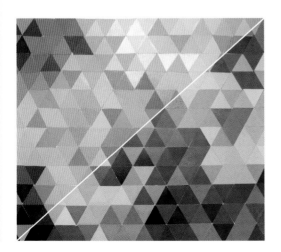

Seed of Life

For centuries, pattern design has been used by artists and craft persons for all sorts of embellishment. Patterns were used for religious purposes in mosques, temples, and churches. They are found in mosaic, stained glass, illuminated manuscripts, textiles, flooring, woodwork—you name it. The Renaissance (around 1500) emphasized naturalism, the style of art by which the art looks as much like real life as possible. Thus, for the past 600 years, pattern art has been regulated to the "decorative" and has been much less honored than naturalism. In the past one hundred years or so, art history has shifted to include "abstract" art in the high art lexicon (think the drippy paint canvases of Jackson Pollock). But pattern art and design is still generally regarded as "lesser." Overall it seems that pattern art is the province of so-called women's work such as stitchery and scrapbooking. There is probably some latent sexism/classism imbued in the bias since any cursory glance at the celebrities of art history from the Renaissance right up to the present day will turn up mostly Caucasian males. But hello. It's a new dawn. The future, as they say, is female.

SKILL LEVEL
Moderate

SKILLS LEARNED
Granulation

MATERIALS
Templates:
- Seed of Life: Simple, page 145 (shown in project on page 94)
- Seed of Life: Advanced, page 146 (see finished art on page 13)

12-color watercolor kit (see page 19)
#2 and #4 round brushes
Paper towel

MESS LEVEL
Minimal

TIME TO COMPLETE
45–60 minutes

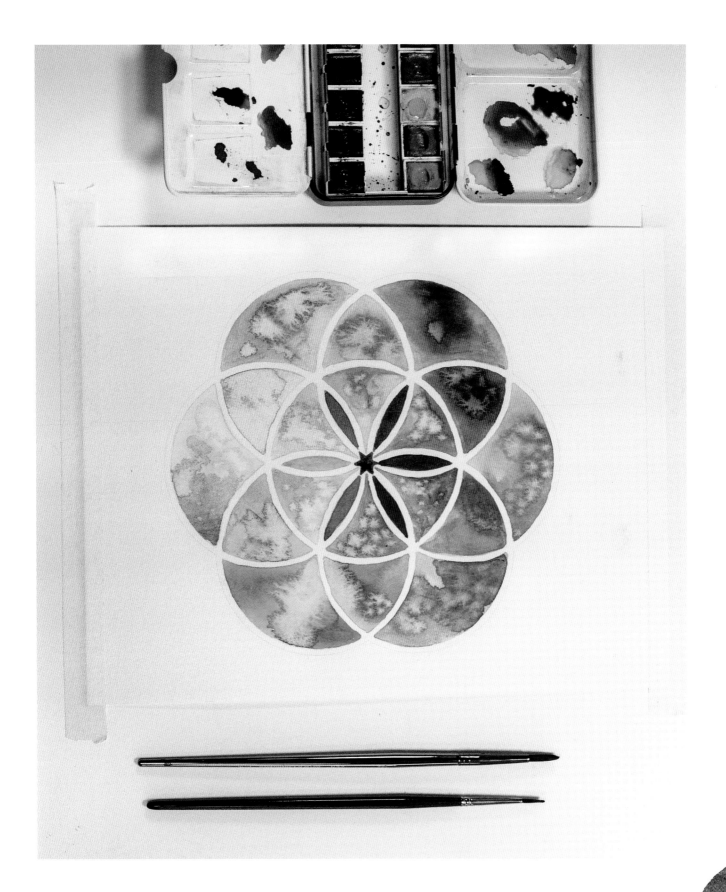

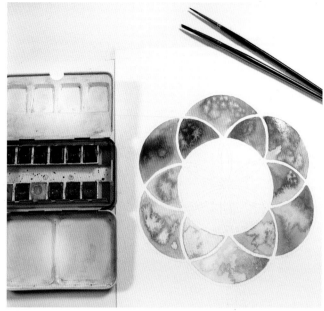

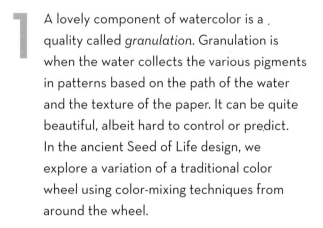

1 A lovely component of watercolor is a quality called *granulation*. Granulation is when the water collects the various pigments in patterns based on the path of the water and the texture of the paper. It can be quite beautiful, albeit hard to control or predict. In the ancient Seed of Life design, we explore a variation of a traditional color wheel using color-mixing techniques from around the wheel.

2 Try the following techniques to get the colors to pool, crystalize, and concentrate irregularly.

Paint will act differently depending on how wet it is (shiny wet versus damp, for instance). It will also act differently depending on your paper and the type and color of paint. Some ways to experiment with wet on wet:

- Brush on clear water. Drop in paint.

- Paint on a color. Drop in water.

- Paint on a color. Wait till it's damp and then add tiny drops of water to get little crystals. (For more on this, see Diamond Crystals, page 96.)

DEADPOOL

If things get too wet and water is pooling, use a paper towel to absorb the extra liquid.

Developing Your Fist

During World War II (and you just know it's going to be a good story about art when it starts off with World War II), telegraph operators were the key agents of war communication. Naturally, all the messages were encoded, but the opposing army code breakers learned they could recognize an operator simply by how she delivered the code. (I'm not using "she" just for inclusion here; WWII Morse code operators were often women.) Even if they couldn't decode the actual meaning, they could tell who was delivering the message because of distinctive characteristics in the execution. They called this personal style a *fist*.

It seems to defy logic—Morse code is essentially just a system of clicking buttons. Yet somehow the expert telegraph operators developed their own timing, rhythm, style, and delivery completely distinct from other operators. I am reminded about the Morse code fist when I teach workshops and give everyone an identical template and identical instruction. Lo and behold, every single one of these novice painters will approach the project completely differently. Even if every person was painting a series of red hexagons, it was easy to see unique features and styles between each artist. Often, someone would innovate in a way that I had never seen before.

And I have some good news. And bad news. No, wait—actually, it's all good news! In order to develop your fist, you just have to practice. A lot. When you are pursuing your own creative path for intrinsic reasons, you will naturally find flow, and then you will actually want to do that thing more because flow is so rewarding, and then you will naturally get better at it. Even if you always keep the difficulty level at 4 percent, you will keep improving . . . indefinitely.

When you do something, anything, habitually, you will get very good at how you do it. Like a river finding its course, you will find a unique path to your own expression. This is a highly satisfying journey. However, no water: no river gorge. You need to turn on your tap by working (or, if you prefer, *playing*) to get the flow. When you first turn on the spout, your water will be running across a flat plane with no distinct quality or identity, picking up mud and debris until all you have is a hot mess. This is normal. The only way to clean it up and start to create an adorable little trickle that turns into a creek that turns into a brook that turns into a river is to keep making.

Diamond Crystals

I have a friend who does improv comedy. She took a watercolor class from me and told me it was a lot like improv. "I do something, then watercolor does something!" Basically, watercolor is your partner and will interact with your moves in unexpected ways. My friend Rob sagely says the difference between fighting and dancing is *cooperation*. The number one rule in improv (and, side note, in my life) is you *never turn down a suggestion*. So with watercolor, don't fight with it—go with it. As you get better with watercolor, you will have a better sense of predicting how it might react to your inputs and how to guide it in a way that pleases you. Working wet on wet is a great way to "Let go and let flow."

So many rhymes right now . . . I can't even.

This project sounds fancy, but don't worry—no precious gems will be used in the production of this technique! Also, you don't have to introduce any other solvent or additive to get this effect. You just need water and paint. I admit the timing in this technique is the trickiest part. What you are trying to do is to get the watercolor to create interesting organic "crystal" or snowflake patterns as it dries. To encourage the paint, you need to introduce a tiny bit of water at an exact stage in the drying process. Remember, watercolor is a process of dual cooperation. If it's too wet, everything will run and be a messy blob, and if it's too dry, the water will bead on the page and refuse to do anything interesting.

SKILL LEVEL
Moderate

SKILLS LEARNED
Special effects with watercolor

MATERIALS
Templates:
- Diamond Crystals: Simple, page 147 (shown on pages 98–99)
- Diamond Crystals: Advanced, page 148 (see finished art on page 135)
12-color watercolor kit (see page 19)
#2 and #4 round brushes
Paper towel

MESS LEVEL
Minimal

TIME TO COMPLETE
30-60 minutes

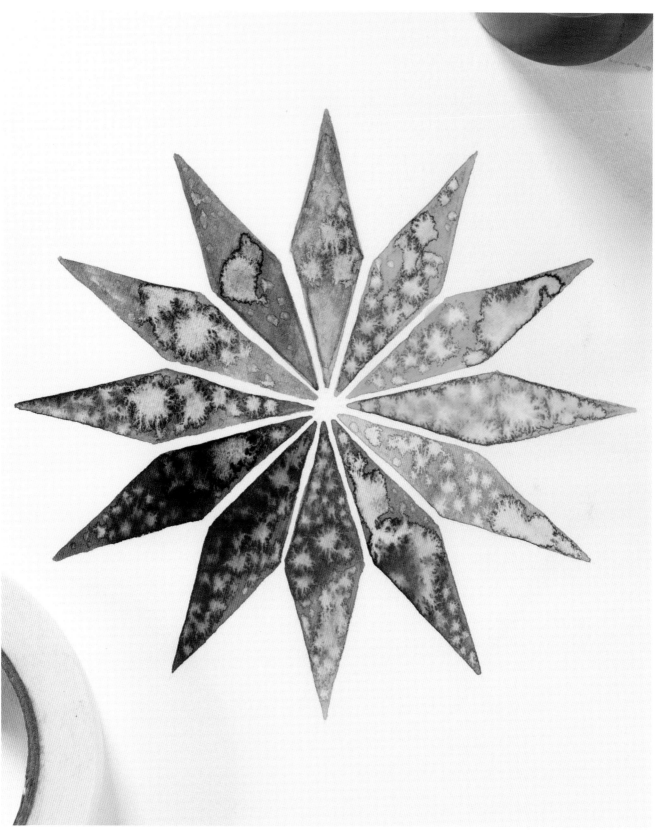

1 Fill in a shape with a fairly concentrated watercolor mix of a color of your choice. It helps if the shape isn't larger than 1 to 2 inches (2.5 to 5 cm). Try to apply the watercolor uniformly. Now, the timed waiting. Sometimes I will move on to another shape and then circle back, or, in this case, "diamond back" (Ha). The time it takes me to fill in another shape is often the right amount of time for the first diamond to reach prime crystal time.

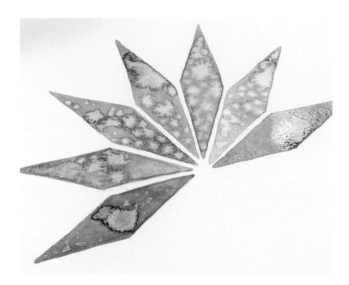

2 The paint should be damp to the touch but not shiny with water collecting on the surface of the paper. If there's too much water on the page, it will look like the orange diamond.

3 Using your smallest brush (a #1 or #2 round), dip into clean water, and tap off the biggest drops. The brush will be wet but not dripping like it is in this image.

4 Use the barest touch of your brush to the surface of the paper, as if you're a fairy putting a freckle on a baby's nose. It's a whisper, and at first you might not even see a change.

But as the paint continues drying, that little bit of water will spread outward and create the crystal structure.

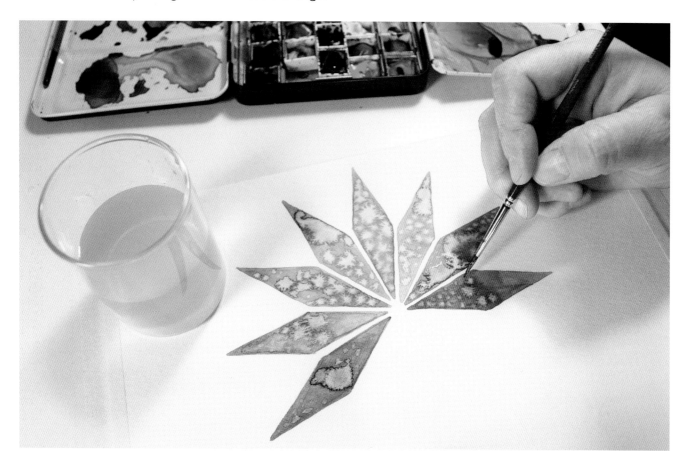

TIME TESTS

It can be helpful to have a test page to try out the timing needed to create the water crystals.

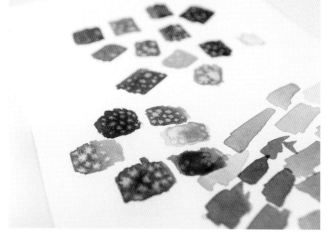

Hex Addict

One of my early memories was getting in trouble when I was at the drugstore with my grandma. She was waiting for a prescription, and while she tarried, I took the time to *rearrange the nail polish display.* This is a true story. Something about the beautiful bottles of color and lack of oversight from an authority figure made me lose my six-year-old mind. I imagined the Walgreens employees were deeply appreciative. I still have this almost irresistible response with nail polish displays, especially at the nail salon, where they don't organize it on purpose. It makes me insane. Luckily, I have paper collage—color I get to organize and no one gets mad.

SKILL LEVEL
Medium

SKILLS LEARNED
Focal points; gradating value; neutral colors

MATERIALS
Craft paper
1" (2.5 cm) hexagon punch
18" x 24" (45.5 x 61 cm) mixed-media paper
Glue sticks

MESS LEVEL
Moderately bonkerballs

TIME TO COMPLETE
60–90 minutes

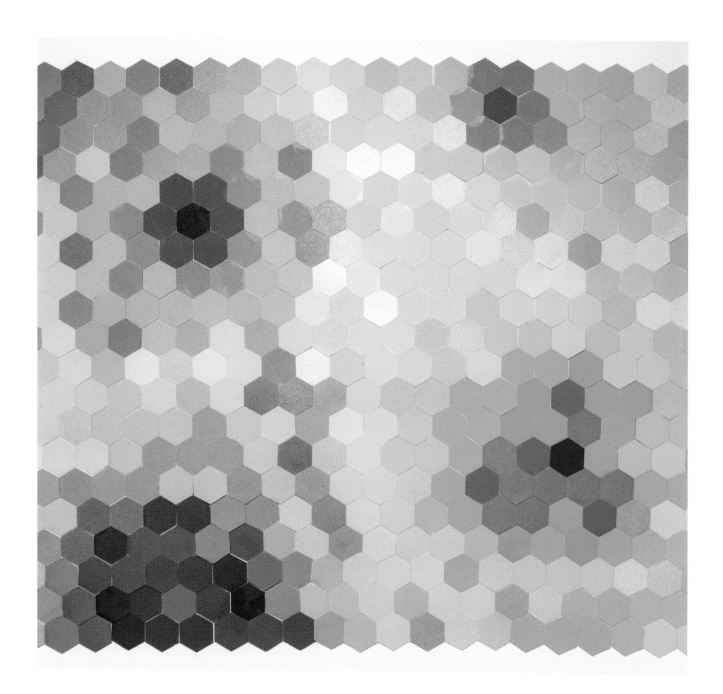

CHOOSING COLORS

Identify a basic color palette by selecting three or four high-chroma focal point colors. I used blue, pink, lilac, and orange.

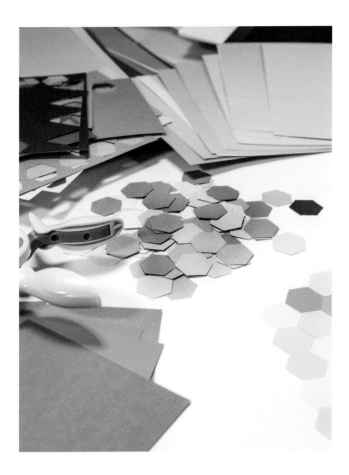

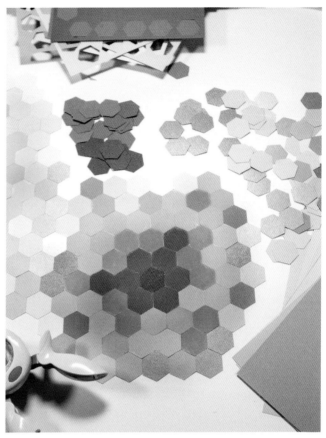

1 The innermost center hexagon is darker, and the next ring out is a little lighter in value, and so on. Hexciting! By the fourth ring, most color has been toned down to a tint (a color with white added) or neutral gray or taupe to prepare to the shift into the next orb of color.

2 Transition to the next ring, this time working from the neutrals to high chroma. A note on perfectionism and mathematical precision: You can exercise that kind of precision with collage, but I think it's usually pretty boring. I prefer to wing it. For instance, my blue orb is much bigger than the pink orb, and it's not supersymmetrical. I think that creates a dynamic composition with unexpected visual interest. Either that or I'm kinda lazy.

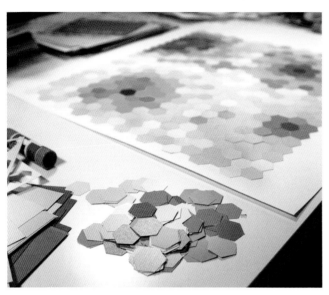

JUST LIKE TILING

The trick to making this mosaic style of collage work is to start in one spot and line things up as carefully as possible or you'll get gaps or overlaps. It helps to stay in more or less circles around your first piece. This design is more forgiving, however, if you build in channels between the paper (like the grout line in tiling).

3 Continue to transition the colors to the next series of orbs. As usual, when I was done, I saw a lot of things that snagged my eye, not in a good way, and I adjusted them by picking a better color and hexing it right on there.

VARIATIONS: SWITCH IT UP

You can do a similar project with triangles and a different color palette. In this project, there's less of an orblike locus, but there are color transitions and large sections of neutral, transitional colors (grays and beiges).

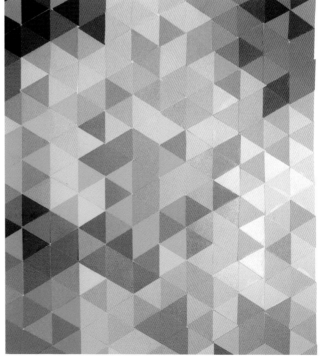

Mandala Hex

You may have heard of the Tibetan Zen monks who laboriously create beautiful and intricate mandalas out of colored grains of sand, spending weeks and months, and then ceremonially destroy them and release the sands into a river. For some people this probably sounds like punishment, but for me it sounds like exactly the kind of task I could use to focus my monkey brain and allow the spirit to run with the wolves. If the monks are hiring, I'm available. Can I bring my husband and my wine and my dystopian zombie audiobooks? (Fun fact: I love apocalyptic fiction.) Oh, maybe those things aren't appropriate for a monk's life? I guess I'll just be over here with my wine, punching teeny, tiny hexagons.

SKILL LEVEL
Moderate to possibly annoying (if you like to knit, you'll like this project)

SKILLS LEARNED
Attention to detail; peaceful om

MATERIALS
Crafter's card stock
Small hexagon punch
12" x 12" (30.5 x 30.5 cm) premade frame
Glue sticks

MESS LEVEL
I found tiny hexes in my bra and in the dog's tail

TIME
A week? A while?

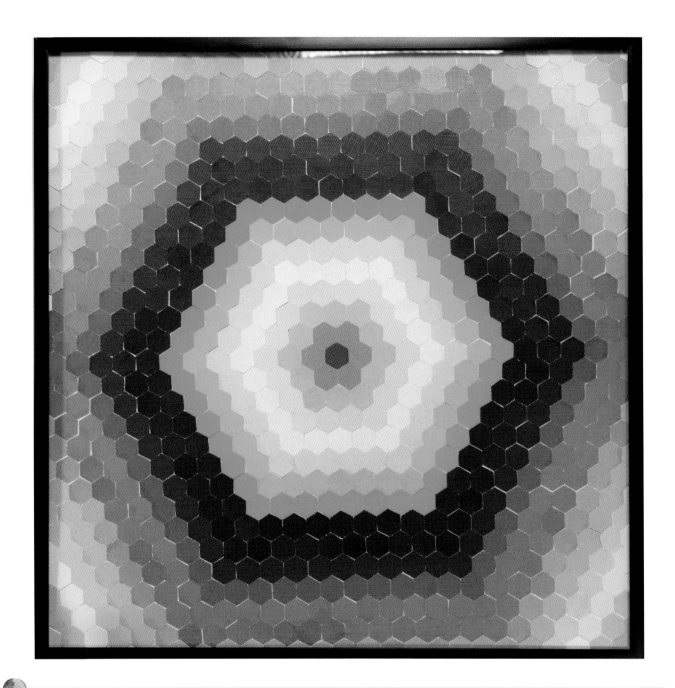

PROTECT YOUR ART

Unlike the Tibetan sand mandalas, this project can be designed to be longer lasting. Using a premade frame with a hardboard backing is a great support for a complicated collage like this (shown: a 12" x 12" [30.5 x 30.5 cm] frame found at Ikea). Glass (or plexiglass) is pretty essential to protect a collage like this for the long haul.

1 Use a ruler to make a mark in the center of your support. I painted my hardboard with white primer first. It makes it easier to see the colors and protects the collage from acids in the material.

2 You can make color decisions at each stage in the rings around the hexagon, or you can roughly plan them out. I did five or six rings in advance. Fan out your card stock colors and reorganize them a bit until you have the color progression you're looking for.

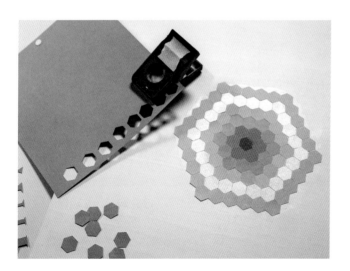

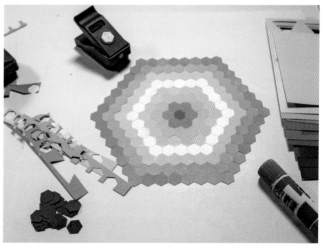

3 Starting from the center mark, apply concentric hexagon rings in connected colors to create a sense of tree rings. It's pretty nigh impossible to avoid getting gunky glue on the tiny hexagons. Even though it dries clear, it can sometimes be seen. Depending on the quality of your card stock, it is possible to wipe off dry glue with a bit of damp paper towel.

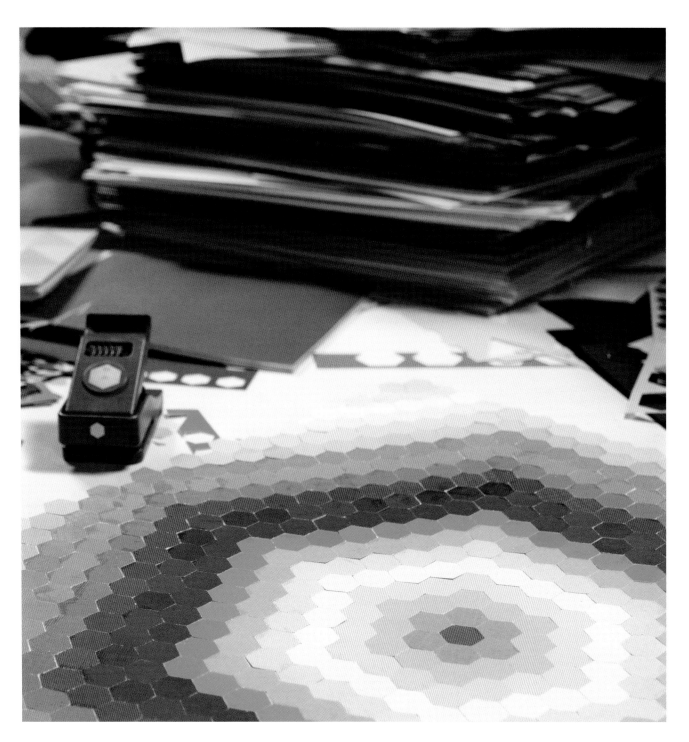

4 Add the collage in rings around the hex until you reach the edge. When you're done, trim the edges, pop it in the frame, and you've got art! Or, ceremonially shred it and put it in the river. Your choice.

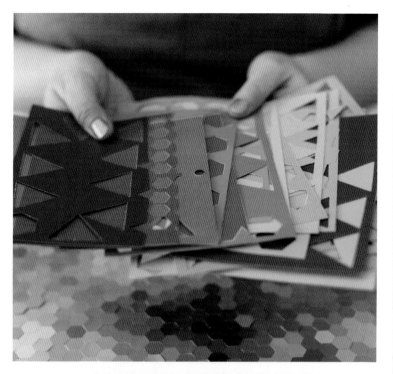
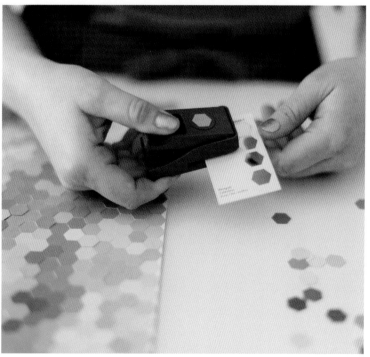
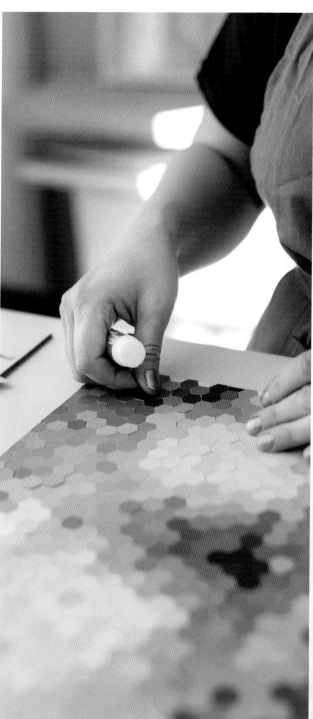

Hex Appeal

Here's round two on grandma stories—this time the *other* grandma. Grandma Gladys was a pie-baking farmer's wife, a low-key lady. She did quilting, knitting, and embroidery in her free time, when she wasn't canning and baking bread and taking care of the livestock and children. Her busy schedule meant she was able to knit a full-size blanket and/or sweater only once every two weeks or so. And crochet some doilies and embroider some dolls' dresses and darn socks and beautify her kitchen towels with applique flowers and prep the house for Christmas with all handmade décor. Anyway, the only time I saw her mad, literally spitting mad, was when I found her embroidery thread box and decided to "rearrange" it. My method was to unspool all her embroidery thread from their holders and carefully pile them up on her bed. (I had removed the quilted blanket to better see the colors on the white sheets). Well, you can see where this is going. When Grandma found me, it must have appeared as if a cloven-hooved devil was cavorting on her disheveled marriage bed while tossing her treasured thread in the air like confetti. For the record, that's not what was happening. Everything I was doing made sense to me at the time—and still does. (For reference, see how I rearranged the Walgreens nail polish display with Grandma Cleo on page 100.)

SKILL LEVEL
Moderate trending to absurd, if you like that sort of thing (I do)

SKILLS LEARNED
Intuitive color

MATERIALS
Crafter's card stock
Decommissioned paint chips
Glue stick
Small hexagon punch

MESS LEVEL
Not permanent, but prodigious. Picking tiny hexes out of carpet is not my favorite.

TIME TO COMPLETE
2–3 hours

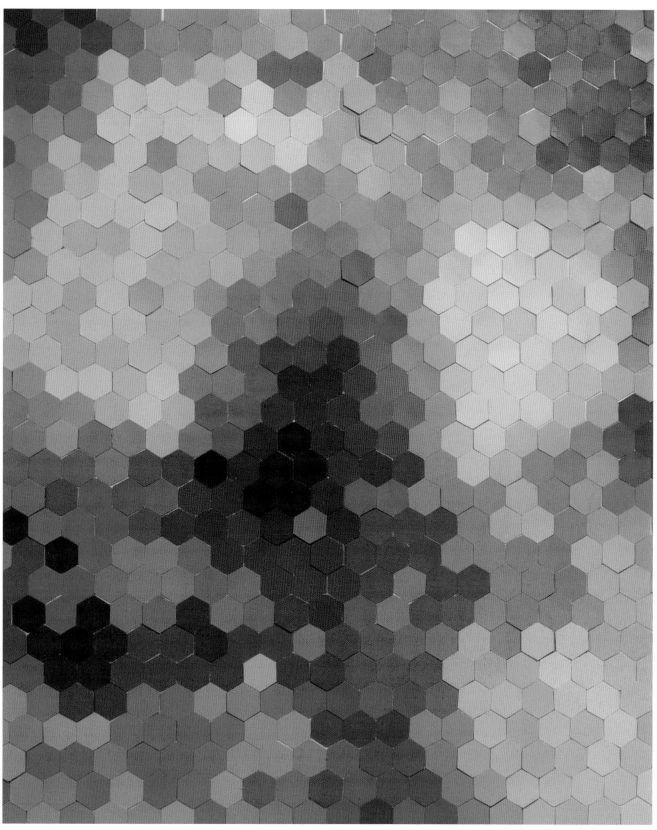

1 Like the Mandala Hex project (see page 104), I used a 12" x 12" (30.5 x 30.5 cm) pre-made glass frame with a hardboard backing (painted white). For this type of project, I work intuitively from section to section, following the three main color-mixing techniques (*around the wheel, across the wheel,* and *up and down value*). Depending on the available color range of the source material, the goal is to make all of these transitions throughout the whole. I was fortunate to be given a couple of books of '80s interior-decorating color chips, and those served me beautifully for this project (thanks, John A). Standard crafter's card stock will work as well.

2 Start in the center of the frame and find a rhythm of punching and gluing. I punch twenty or so different colors and apply ten, and keep up that rhythm till I have a *mountain* of extra hexes.

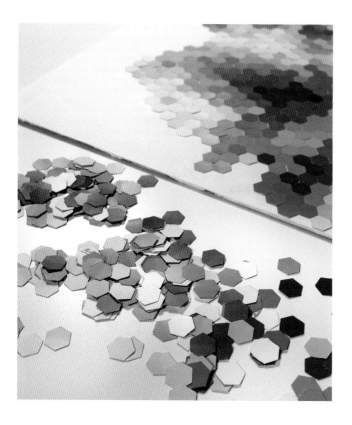

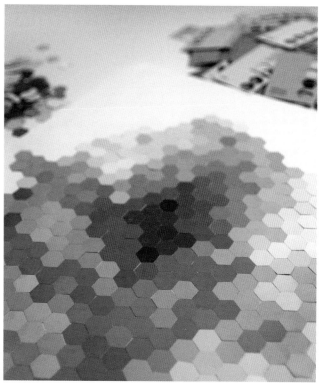

3 When applying, it's easy to get the hexagons slightly off-kilter. Gaps may develop here and there. Not being a perfectionist, I usually just compensate for these gaps by doubling up and overlapping hexes when needed.

4 Cover the whole surface, then trim the overhanging hexes from the sides so that they will fit in the frame. It works best to trim these when the glue is dry. Sometimes, after I cover the whole surface, I add more hex colors in different spots to make sure the overall composition is pleasing to me.

A NOTE ON COLOR

Sometimes it's difficult to fully assess a color unless it's in context of other colors. Frequently I think I've found the right transitional color and discover that it isn't the right fit after all. That's why I punch so many colors—I want to make sure I have lots of options.

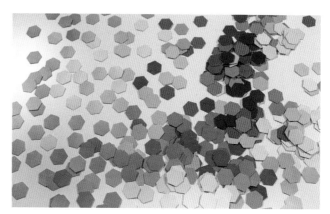

Sashiko

I've been painting this pattern for a while now. I love the multiple internal shapes—triangles, hexagons, and stars. A lot of my designs are actually variations on ancient motifs found in tile and other applied arts. This design and the art on the cover of this book are reminiscent of a style of Japanese stitching design called Sashiko that originated in the 1600s. Sashiko handwork was traditionally made with a white embroidery geometric pattern hand-stitched over dark navy cloth. I found this particular pattern as a stencil in a craft store. And fell in love.

SKILL LEVEL
Moderate to difficult

SKILLS LEARNED
Analogous color

MATERIALS
Template: page 149
12-color watercolor kit (see page 19)
#2 round brush
Paper towel

MESS LEVEL
Minimal

TIME TO COMPLETE
60 minutes

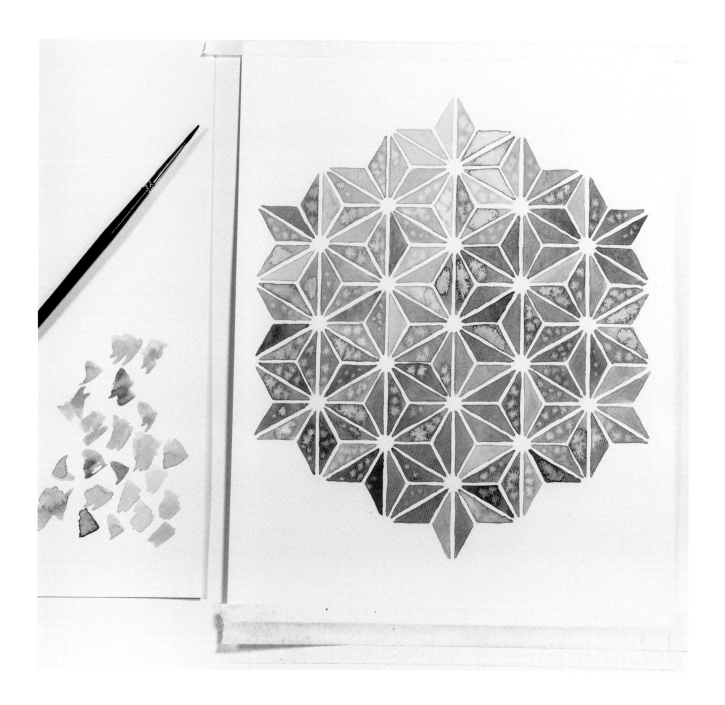

CHOOSING COLORS

The main colors used on this painting were opera pink, phthalo green (blue shade) and phthalo blue (red shade), and imperial purple.

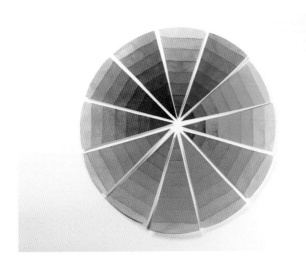

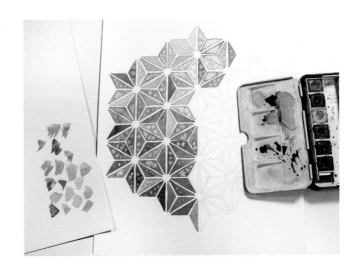

1 This painting is made using analogous colors. Analogous colors are those that are next to one another on the color wheel.

2 Use a #2 round brush or smaller to paint the tiny triangles. Outline each shape with the color and then fill it in. These tiny shapes take a steady hand and careful attention to detail. Some artists use masking fluid to achieve a hard edge and intricate detail, but I have not found that to work very well. It is tedious to apply, requiring the same steady hand you'll need to paint the shapes, and it causes more problems than efficiency. Since I'm right-handed, I usually work left to right on these complicated designs so that I don't drag my fist across wet paint.

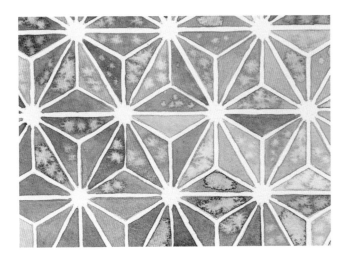

3 Mix the paint using The Mother Method (see page 13). Paint each triangle a slightly different color than the one before so that the pattern gradually changes as it moves across the page. You can use the water crystals technique (see page 99) to create tiny blooms in some of the triangles. This also generates intriguing textures.

Enemies of Flow

Let me be clear. There are enemies. There are enemies that want to prevent you from discovering something new. There are enemies that want to keep you in your safe, private, TV-watching world. All of those enemies are located pretty much in one place: your own head.

Now, I'm not opposed to your brain. It's your prefrontal cortex we've got to deal with. As we've discussed, that's the part of your brain that's in charge of extremely important human skills, like complex planning, personality expression, reasoning, and judgment. You would think those basic life skills all seem like helpful things when you are trying to create something, but here's the problem: The prefrontal cortex is extremely conservative. Studies have shown that social stresses (like public speaking or—gasp—a public art exhibition) are to our brains equivalent to life-and-death stress, like being stalked by a tiger in the woods. Who wants to eat you. Who might not kill you before he starts eating you. This is how most people feel about public speaking, amiright?

So your prefrontal cortex—in league with several other survival-centric parts of your brain—would like to talk you out of taking any kind of risk that is outside the very safe, known confines of basic survival. And to make sure you get the message, it offers you several strong impulses in times of experimentation. Be on the lookout for the following:

- Perfectionism
- Procrastination
- A negative script about your efforts (see Art Scars, page 77)
- Constant comparison

Perfectionism and procrastination go hand in hand. We know that we get good at something when we do it a lot (fun!), but when we want to learn a new skill, it is hard and awkward at first (not fun!). So because we're not cool with the necessary failure that's inherent in new learning (prefrontal cortex screaming danger!), we procrastinate starting something new (fear). Yes, procrastination is a function of fear, not laziness. Not doing the dishes is probably laziness. Avoiding starting a new, untried, and untested project is probably fear. Meanwhile, when we get around to actually making something, to mitigate our anxiety with the land mines of failure looming at every brush stroke, we are constantly saying to ourselves or others: "This sucks, I'm not artistic, I don't have talent, this isn't good, everyone else's is better."

The prefrontal cortex is there to help us survive, so it's unreasonable to ask it to shut up. It's like holding back the tide. Can't fight city hall, and you can't fight your brain's powerful wiring. But we can set up conditions for it to quiet down. Make a list of known flow triggers and *do those things* more. In new activities, follow the 4 percent difficulty rule. Discipline yourself to not mutter curses and insults at your efforts. Treat yourself like a beloved child. All that constant jabber-jawing, thinking, planning, self-conscious reasoning will be set on mute.

Radiating Diamonds

Let's talk about steady hands for a second. I do not use masking fluid. Truth be told, one would have to have a steady hand to apply the masking fluid the way I need it, so what's the point? No time savings whatsoever. In the social media comment world (there's always good stuff to read at 3 a.m. when I can't sleep), there are people who insist that I use some kind of aid to achieve my hard edges. Masking fluid. Tape. Witchcraft. Wizardry. Nope, just the steady hand given to me by the good lord. Also, probably, the muscles in my hand I've built up over the years (and yet, my hands look so feminine). By the way, I'm really good at painting trim, and I never tape. I'm pretty sure the steady hand is a learned skill, so if your edges look kind of wobbly, don't despair—you'll get better.

SKILL LEVEL
Moderate

SKILLS LEARNED
Transitioning wet-on-wet color

MATERIALS
Template: page 150
12-color watercolor kit (see page 19)
#2 round brush
Paper towel

MESS LEVEL
Minimal

TIME TO COMPLETE
60 minutes

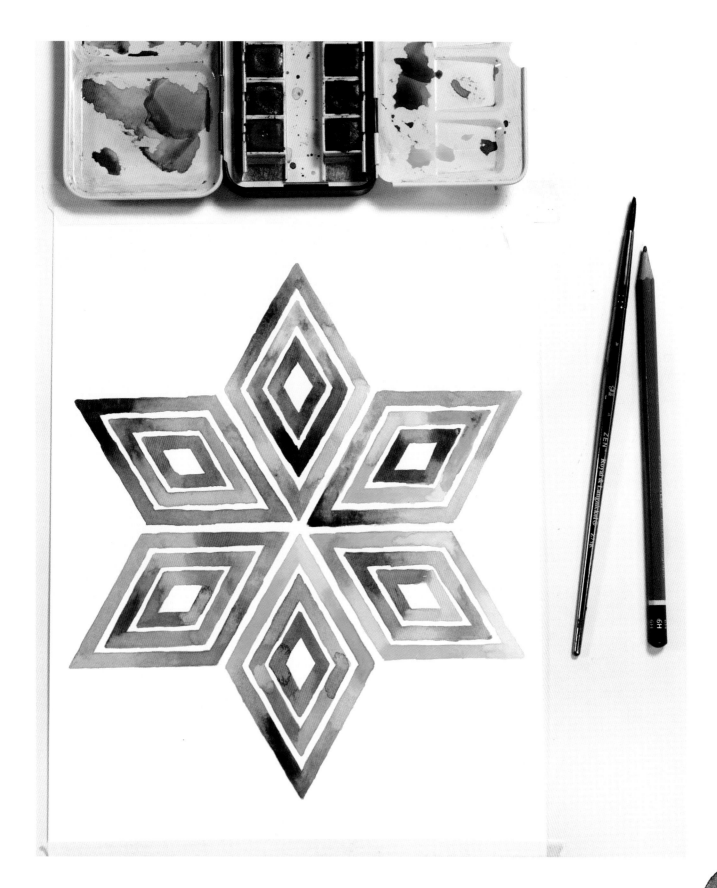

1 Making watercolor patterns glow and shimmer is extremely satisfying. In this design, I transitioned the color to gray, white, or another color across the span of the diamond-shaped band. Watercolor will tend to stay where the paper is wet. That means you can lay down a fairly complicated shape just with water and the color will stay within its bounds when you drop it in. If you have too much water, then water can start to pool and drip.

2 To get this method to work, you need to capitalize on the wet. Start at one point of the diamond and pull a concentrated color down either side from the point. With the color still quite wet, introduce the next color or more water.

3 The two colors will interact in interesting ways and naturally create value transitions that seem to pulsate. You can experiment by painting the entire shape with just water and then dropping color in at different points.

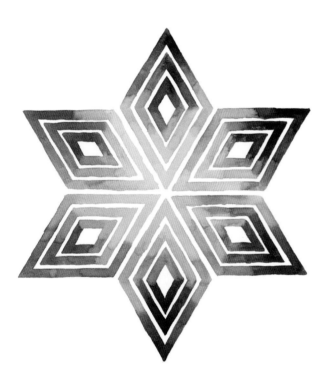

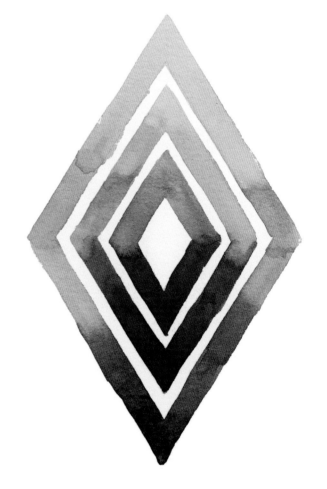

4 For this star, I concentrated the paint on the exterior point of the diamond, and when I had painted a V in highly saturated colors, I added more and more water to fill the entire shape.

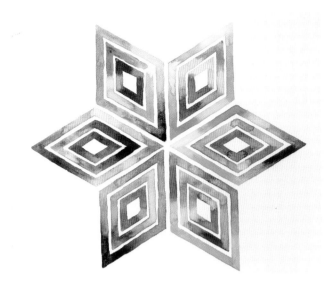

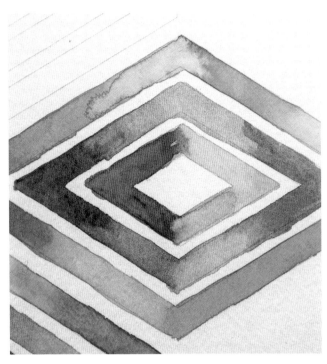

5 For this look, I immediately transitioned one color to a completely different color. I was somewhat random about my color choices.

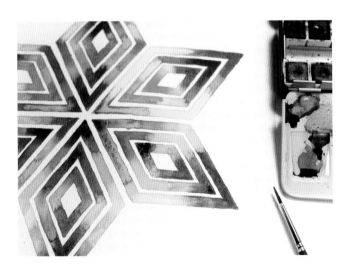

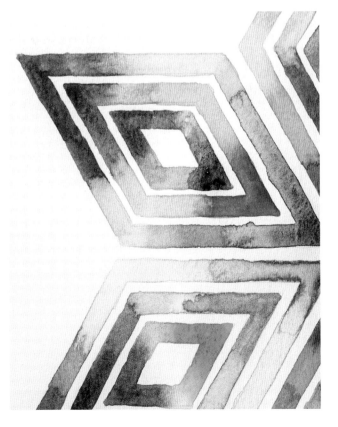

6 For this dramatic little number, I introduced a hand-mixed gray/black made with a blend of imperial purple, indanthrone blue, and lemon yellow. I kept the color the same for each ring in the star, with slight variations of tone.

Antagonistic Complements

I don't know why they call them complementary colors, because frankly I don't think there's much complementary about them—in fact, they clash. The pairs are made of colors that are across the pie from each other on the old standby color wheel. Red/green is one complementary pair, blue/ orange, and yellow/purple to name a few. Certain holidays notwithstanding, these are the combos your mom told you not to wear at the same time. I would much prefer to call them antagonistic colors.

But here's the magic. If you mix two analogous colors together, like blue and purple, you get blueish purple. But if you mix a complementary set together, Bob is your freaking uncle. You have unlocked the door to beautiful neutrals and grays and toned-down primaries that will have you painting hexagons for years. Two complementary colors can be mixed in various amounts to create a bajillion different tones.

SKILL LEVEL
Moderate

SKILLS LEARNED
Complementary colors

MATERIALS
Template: page 151
12-color watercolor kit (see page 19)
#4 round brush
Paper towel

MESS LEVEL
Minimal

TIME TO COMPLETE
60 minutes

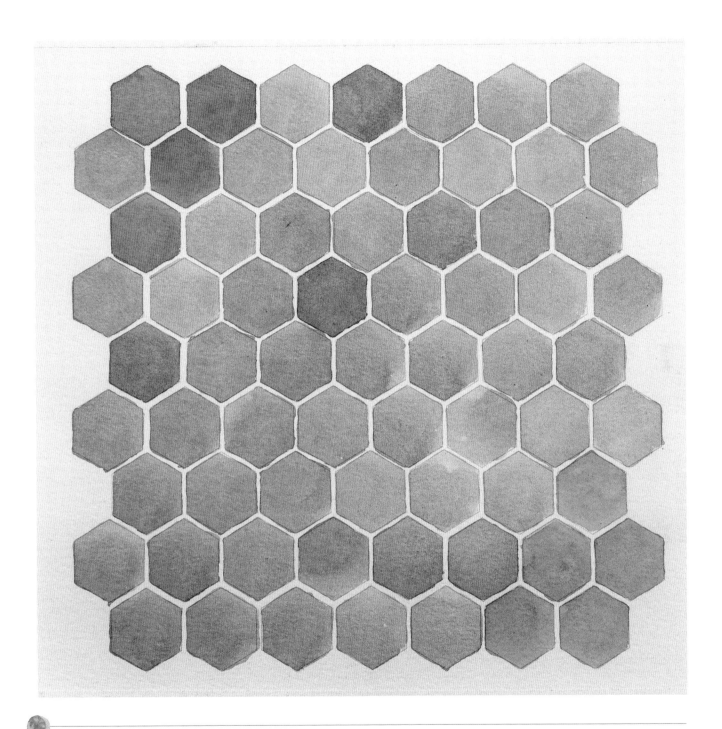

CHOOSING COLORS

For this project I used two of my favorite watercolor colors from the standard kit, quinacridone coral and phthalo blue (green shade), which is basically greenish turquoise.

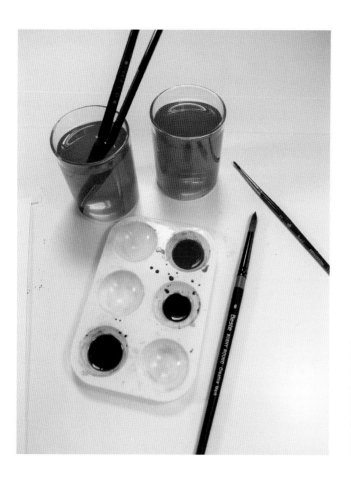

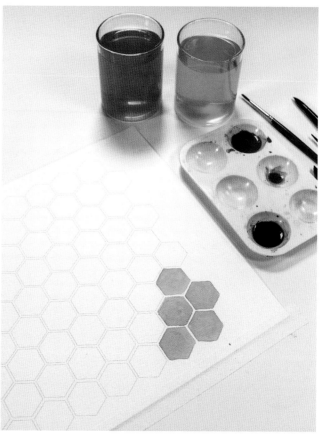

1 Use the paint palette with small wells to mix up the pure colors into the value strength you want. A blotter sheet is key because it's impossible to gauge the strength of the color in the mixing palette. Start laying down the two pure colors on whichever opposite sides you designate.

2 You should have a decent amount of watery coral in the proper strength in your mixing well. Those two are your Mother paints (see page 13). By dipping and swabbing your brush, transfer some of those pure colors into a second well. You should end up with four wells of two pure colors.

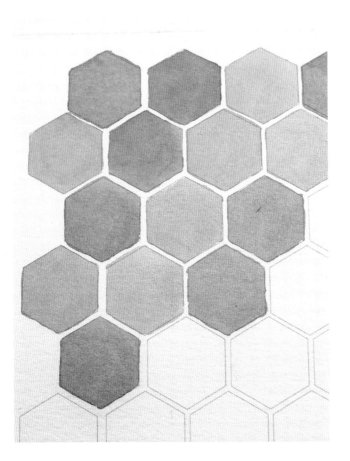

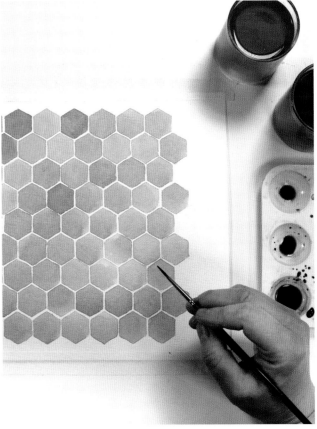

3 To achieve the next color transition, a little goes a long way. With a rinsed, clean brush, dab the watery turquoise paint the tiniest bit and mix it into the coral. Use the blotting sheet to gauge the color. For the first color shift, the color should still look coral, but the tiniest bit duller.

4 Continually add a tiny drop of pure turquoise to your mix and paint your way down the hexagons. The middle area should look fairly neutral, a nice gray, neither reddish or bluish.

Faded Hex

If you run a casual Google search on "color harmony," you will get a lot of theories. Many people have sought to find a "rule" of color harmony, some kind of computation that can be applied to different colors in different situations and, hey, presto! That color combo looks amazing! But can there be consistent, peer-reviewed rules assuring us color harmony? Good news! There's actually a formula for that very thing:

*Color harmony = f (color 1, 2, 3 + n) * (ID + CE + CX + P + T)*

The formula's author, Zena O'Connor, says (see page 157 for the citation):

In line with current theoretical paradigms, the conceptual model is essentially probabilistic rather than predictive; plus it is idiographic rather than universal and deterministic . . .

Wow, thanks for . . . explaining. If you had trouble following that, don't worry, I speak grad school! What O'Connor is saying with her formula is that color harmony is dependent on individual preferences, settings, social trends, and mood. In a nutshell, color harmony is completely subjective. Right. Got it.

So now we've established that universal color harmony is a fruitless pursuit. I'm sorry.

SKILL LEVEL
Moderate

SKILLS LEARNED
Gradients, color shifts

MATERIALS
Template: page 152
12-color watercolor kit (see page 19)
#4 round brush
Paper towel

MESS LEVEL
Minimal

TIME TO COMPLETE
60 minutes

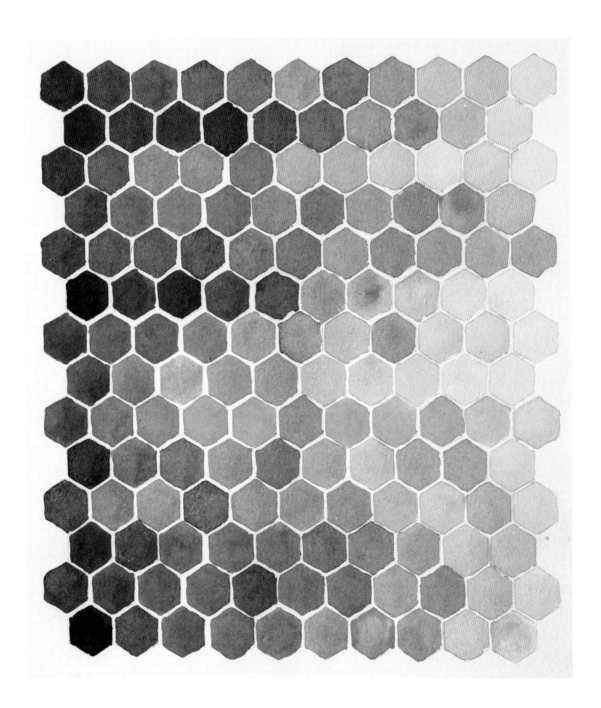

CHOOSING COLORS

The color scheme I used is basically a toned-down spectrum. I maximized high drama by really amping up the dark colors.

1 These hexes really ring my current theoretical deterministic paradigm for color harmony. There's something about this pattern (obviously, hexes are a long-term obsession), but also the transitions with the jewel tones.

2 This project combines all of The Mother Method (see page 13) paint transition techniques: *around the wheel, across the wheel,* and *up and down value.* And beehives, obviously, so that really takes it up a notch. Rarely did I use an unmixed color straight from the pan, and I did not clean my palette in between mixing. When I don't need to have a highly saturated, pure color, I enjoy the grittiness of an unwashed palette. Actually, I enjoy the grittiness of a great many unwashed things, but that's for another book.

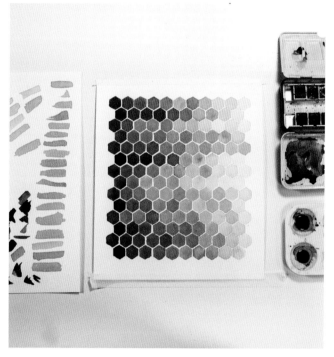

3 All the colors used are mixed to some degree by their complement and the next color line. Working from dark to light, use the same batch of color for each line of hexes and gradually add water.

4 The tiny scale of the hexes takes some patience. If you look closely, you will see a lot of imperfections in the execution.

More Enemies of Flow

Other enemies of flow and creativity:

- Narrow definition of what creativity is
- Expectations of ourselves
- Unreasonable expectations of our abilities (linked to perfectionism)
- Overvaluing what other people expect or wish us to do
- Associating creativity with poverty
- Associating creativity with eccentricity
- Conformity
- Convergent thinking
- Unwillingness to let go of old patterns
- Feelings of inadequacy
- Fear of judgment
- Fear of vulnerability
- Inability to deal with our subconscious or deeper feelings
- Unwillingness to be a "novice"
- The myth of "talent" (and fear we don't have it)
- The conception that people who are really excellent at something do it effortlessly
- Feeling like our efforts are insignificant or childish
- Feeling that everything has been done before
- Judgments about other people's "bad art"
- Overemphasis on creative surrogates—other people that are makers; drugs and alcohol; or other ingestible chemicals (such as Doritos); various entertainment (such as Netflix)

Working with Neutrals

At heart, we're all four-year-olds. Or birds. Or four-year-old birds. We like brightly colored things and shiny objects. But, if you throw all the highly saturated color-wheel colors at a painting, things can get a little overwhelming. You might end up with a symphony in which every musician is using the flute and is playing *their own song*. And I never liked the flute much.

In these last few projects, we dig deeper into combining complementary colors to create neutrals and grays and mid-tones. The next three paintings are all about how to tone down the color in certain areas to allow other areas to dominate the eyes' attention. The two main ways to tone down color are to go up and down value (tints and shades) or to blend across the wheel by combining complements. When a color becomes a shade or a neutral, I call it "grayed out." As you know, I don't use white or black paint with watercolors, so these projects will be about creating shades and neutrals out of the standard twelve watercolor kit colors.

SKILL LEVEL
Moderate to advanced

SKILLS LEARNED
How to mix neutrals and gray

MATERIALS
Templates:
- Neutral Dots, page 142 (shown in project on page 132)
- Simple Star, page 153 (shown in project on page 133)
- Advanced Star, page 154 (finished art shown opposite)
- Pink Champagne, page 155 (shown in lesson on page 134)

12-color watercolor kit (see page 19)
Various round brushes
Paper towel

MESS LEVEL
Minimal

TIME TO COMPLETE
60 minutes for each painting

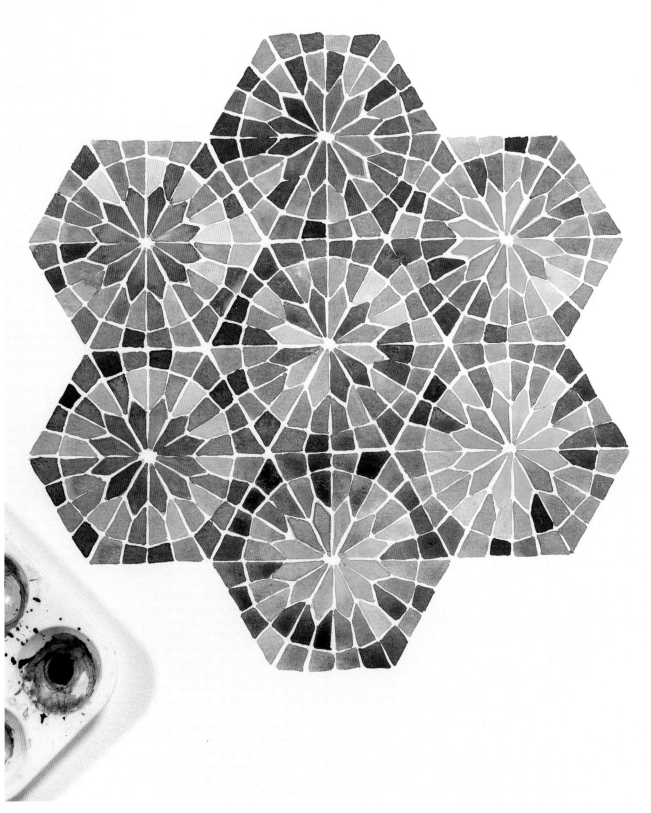

NEUTRAL DOTS

With these dots, we're using the same pattern as the dots color chart (see page 74). In this case, however, the dots are neutralized with their complement.

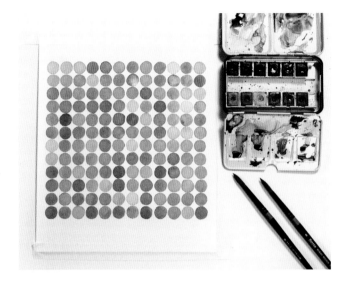

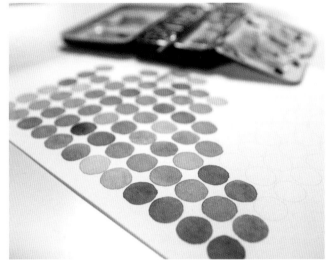

1 I selected five dots out of 144 to be my highly saturated focus points. Note how the eye really jumps to those particularly bright dots.

2 To make this painting, I planned ahead a little and selected two dots for the bright treatment. I wanted the colors around them to be linked to them but grayed out.

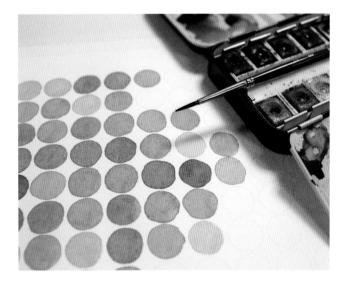

3 In the case of the coral orange dot in the upper middle, I surrounded it with other coral dots, but coral dots that were grayed out. I made sure not to create any color that would compete with the one bright coral dot in that area.

SIMPLE STAR

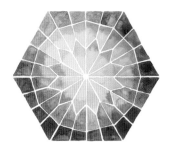

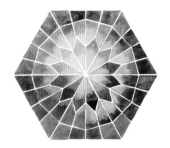

1 Note the difference between these two images. They are the exact same patterns. Above is made with colors around the wheel and up and down value; above right is painted with dark neutrals on the outside shapes, leading the eye to the highly saturated colors in the center. Both approaches have their merit, but above right has additional drama.

The image at the beginning of this project (see page 131) has the exact same pattern repeated seven times to create a recurring motif. The outside edges of the pattern are painted in a dark value with each color's neutral. To achieve this, mix a color with its complement.

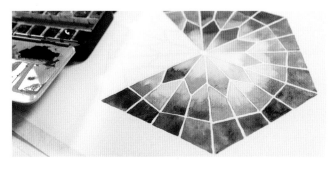

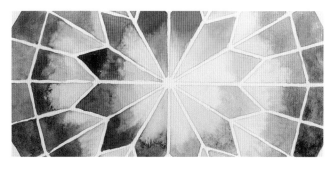

2 The middle ring is a slightly more saturated version of the color that fades into a lighter tone toward the center. To achieve this, mix a concentrated version of the color and paint it on the upper third of the shape. Dip your brush and, with a bit more water introduced, pull the still wet darker color down and in.

3 For the center diamonds, use a pure, unmixed paint tray color and incrementally add water to create a gradient inward.

WATER CONSERVATION

Be conservative about the amount of water you introduce to avoid pooling. Too much water on your brush will flood the whole shape and make an elegant gradient difficult to achieve.

PINK CHAMPAGNE

1 Use your gray skills from Antagonistic Complements (see page 122) to mix a nice pot of warm gray paint. Hmm, that sounds delicious! Gray paint soup, coming up.

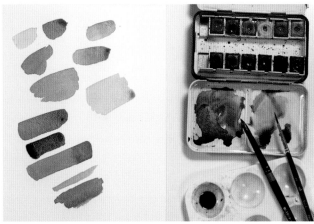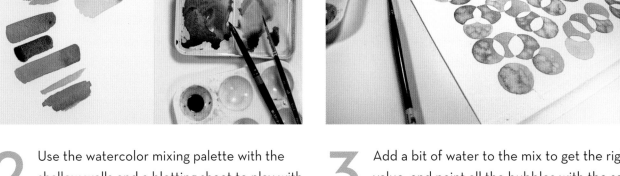

2 Use the watercolor mixing palette with the shallow wells and a blotting sheet to play with the colors until you get a gray that you like. I used quinacridone coral and phthalo green (blue shade) in various amounts until I landed on the perfect midtone neutral.

3 Add a bit of water to the mix to get the right value, and paint all the bubbles with the same color, but avoid painting the areas where the circles overlap. I added some water crystals to play up the granulation and enhance visual interest.

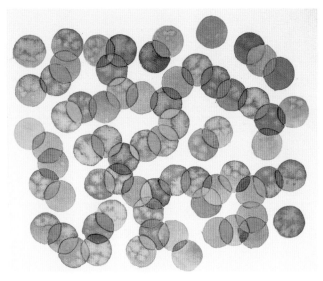

4 When the gray is dry, mix up saturated blends of coral and opera pink with a little bit of added yellow here and there. You can see that the pink really pops out of the gray bubbles.

Final Thoughts: Painting Heaven

In the university painting class I taught that included those charming senior citizens, there was a gentleman whose painting style was already quite distinct when he started the class. About midway through the program, he began a conversation with me by saying, "I don't gamble." You don't? "And I don't drink, or cheat people, or run around with women." I had no idea where this was going. His name, by the way, was Christ. Not kidding. He pronounced it with a short "I" as in, crispy. Chris-t. "I'm almost eighty-five, and I don't have very many more years left, and I was just wondering, if you wouldn't mind, please consider telling me what you think . . ." (bracing myself now) ". . . I'm wondering how much better I should be at painting before I can paint heaven."

The story unfolded. Christ, devoutly religious (which really seems the only option for him), had been wanting to paint his depiction of heaven as described by the apocalyptic literature in the Bible, all streets of gold and the Lord like a waterfall, and angels covered all round with eyes and wings. And while he felt that his good moral character would pass muster with the heavenly host, he wasn't sure that his art skills were quite up to the high call.

My strong advice to him, and to everyone, is *start immediately*. If unimpeachable artistic mastery is your goal before you begin your high call, you will never achieve it in this life. But if you plunge in, heel to scalp, and paint your heaven, you will encounter the divine.

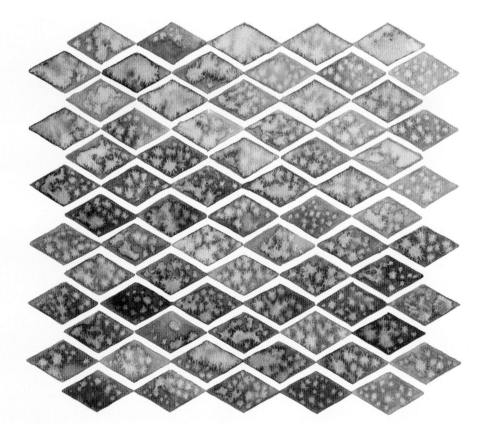

Diamond Crystals: Advanced (see project on page 96 and template on page 148)

Practical Considerations for Sharing Your Work

Since you are definitely going to want to share your cool new artwork with the world, it might help to have a few tips on photography and editing. You can have amazing art, but if your photography of it is subpar, no one will be able to appreciate it. Most phones have great cameras these days as well as photo-editing capabilities. Instagram and other social media apps have photo editing built in.

The two main approaches I use for shooting art for social media are the *tight shot* and the *wide shot*, which includes art supplies and possibly the artist's hand. The latter approach is also called a *flatlay* and is very popular for showing art and tools used in the process. You can also shoot your work from *different angles*.

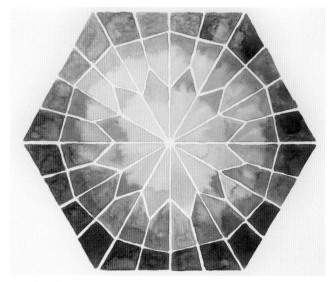

A tight shot

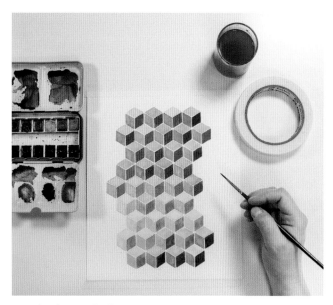

A wide shot or flatlay

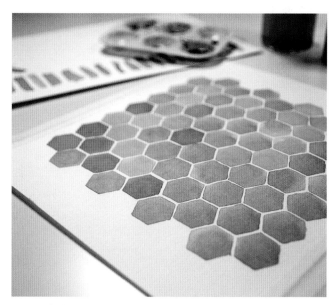

An angled shot

The main thing to keep in mind is lighting, lighting, lighting. Most household lights have a very warm (orangeish) tone that will make your art look unprofessional. It's best to use natural daylight (I've found that outside with a cloudy sky is the best). An art station by a window can work well. Avoid direct sunlight. If you want to upgrade your lighting, I use led light panels or bulbs with a Kelvin temperature of about 6000K. The Kelvin number describes the warmth of the light. For reference, daylight is about 6000K, most household lights are 3000K, and candlelight is 2000K.

I usually take ten to fifteen shots of something I want to post and pick the best one. I look at the composition, the lighting, the shadows, the focus, and the overall content. Taking a lot of shots to get one winner is pretty standard with photographers. I read once that for every photograph published in *National Geographic*, there were an average of 3,200 supporting shots of the same subject.

Your editing style will be unique to you. I like a superbright white image with saturated color, but your preference may be more golden and soft. I never use filters, but I think there are some cool apps that provide some of the effects that I mention here. I find that every image needs a slightly different touch and filters are too samesy.

For my particular style, when I'm editing, my go-to edits are:

- Cropping, depending on the social media format I'm working with

- Brightness, usually more

- Contrast, usually more

- Whites, usually more

- Shadows (I play around with this)

- Structure/clarity/sharpness (it's called different things). I usually turn structure way up but be warned, it's not flattering on skin.

- Vibrance/saturation (I usually turn it up a little)

When you share projects from this book, tag them #colorcompanion to find the color community!

Templates

Download templates at www.josielewis.com
and quartoknows.com/page/color-mixing

Value Gradient Primer: Variation *See page 48*

Dots *See page 74*

Neutral Dots *See page 132*

Waiting for the Diamonds: Triangle Variation *See page 87*

Seed of Life: Simple *See page 92*

Seed of Life: Advanced *See page 92*

Diamond Crystals: Simple *See page 96*

Diamond Crystals: Advanced *See page 96*

Radiating Diamonds *See page 118*

Faded Hex *See page 126*

Working with Neutrals: Advanced Star *See page 133*

Thanks

Beloved Ryan, I couldn't do it without you. Geraldine, you're my one and only Gigi-bird.

Thanks to my folks, Joel and Kathy, who crafted a full-fledged, wide-open, free-wheeling, oil-painting, good-cooking, horse-riding, target-shooting, Jesus-loving, firewood-splitting creative environment to raise their kids. Thanks to sister Corrie and brother Forest—you're always amazing to me. Keep doing all the things.

No one writes a book alone: Thanks to the team at Quarto, especially Joy and Marissa, and my agent Dawn. Thanks to Amy Louise for talking me through it, *all of it,* and shooting the best pictures of me for these pages.

CREDITS

Amy Anderson Photography

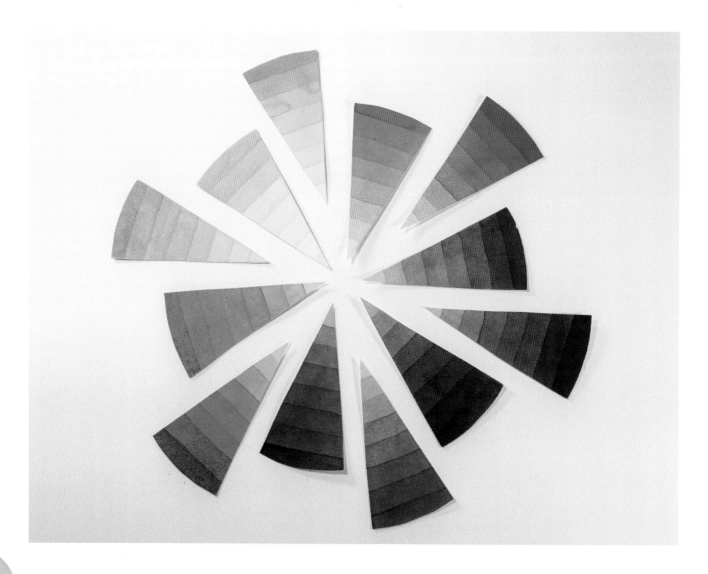

Resources

FIND JOSIE

Instagram:
- **@josielewisart**
- **@colorcompanion**
- **@petrifiedrainbow**

Facebook: @josielewisart
YouTube: Josie Lewis Art
Website: www.josielewis.com

IN PRINT

Albers, Josef. *Interaction of Color.* New Haven and London: Yale University Press, 1963.

Csikszentmihalyi, Mihaly. *Flow: The Psychology of Optimal Experience.* New York: HarperCollins, 1990.

Eiseman, Leatrice. *The Complete Color Harmony, Pantone Edition.* Beverly, MA: Rockport Publishers, 2017.

Finlay, Victoria. *Color: A Natural History of the Palette.* New York, New York: Random House, 2004.

Kastan, David, with Stephen Farthing. *On Color.* New Haven and London: Yale University Press, 2018.

ONLINE

Instagram

Color Factory @colorfactoryco

Craftsposure @craftsposure

Pantone @pantone

The Color Shift @thecolorshift

Websites

Colossal www.thisiscolossal.com/

Design Milk www.design-milk.com

Design Sponge www.designsponge.com

Flow Genome Project www.flowgenomeproject.com/

My Modern Met mymodernmet.com/

IN PERSON

Cooper Hewitt, Smithsonian Design Museum - New York, NY
https://www.cooperhewitt.org/

REFERENCES

O'Connor, Zena. (August 2010). "Color Harmony Revisited." *Color Research and Application, 35(4),* 267–273.

About the Author

JOSIE LEWIS is an artist working in Minnesota. Her current work spans many artistic media, including painting, mixed media, and film. She has artwork in the public collections of Target Corporation, General Mills, Texas School District, University of Texas, The St. Paul Regional Rail Authority, and Minneapolis Public Schools. Lewis has a robust social media following of more than 300,000 on Instagram, Facebook, and YouTube, with more than 200 million views of her process videos. She has been featured by the social media accounts of Design Sponge, I09 World, Reddit, *Good Housekeeping, Elle Décor,* Insider, The Jealous Curator, My Modern Met, George Takei Presents, 9gag, Bored Panda, Mental Floss, and National Endowment for the Arts.

Lewis earned her Master of Fine Arts from the University of Minnesota. She hosts exhibitions and workshops at her Minneapolis studio and lives in the Twin Cities with her husband and daughter.

Index